PARANORMAL LINCOLNSHIRE

DANIEL J. CODD

AMBERLEY

First published 2021

Amberley Publishing
The Hill, Stroud
Gloucestershire, GL5 4EP

www.amberley-books.com

British Library Cataloguing in Publication Data.
A catalogue record for this book is available from the British Library.

ISBN 978 1 4456 9499 3 (print)
ISBN 978 1 4456 9500 6 (ebook)

Typesetting by SJmagic DESIGN SERVICES, India.
Printed in Great Britain.

Contents

Foreword

Over the years Lincolnshire has proved itself a veritable treasure chest of those stories that take us into an abstract realm of weird superstitions, eerie folk tales and supernatural reports. These have ranged from the strangely unnerving, atmospheric fairy tales collected by Marie Clothilde Balfour in *Legends of the Lincolnshire Cars* and published in *Folk-Lore* (1891), to Eliza Gutch and Mabel Peacock's comprehensively researched *Examples of Printed Folk-Lore Concerning Lincolnshire* (1908). There followed the examples of Horncastle-area traditions, collected and published by a Wispington vicar, Revd James Alpass Penny, and the work of Ethel Rudkin in the 1930s. Her *Lincolnshire Folklore* (1936) and research into the county's phantom black hound, Hairy Jack, have become essential references. (Hairy Jack was always black, sometimes a retriever or a sheepdog, with eyes like saucers, and stood table high. You had to be Lincolnshire bred and born around midnight to see it, and it was often considered a guardian apparition.)

In 2007, this author was privileged to have a volume published on Lincolnshire's folklore and enigmas, called *Mysterious Lincolnshire*. In many ways, *Paranormal Lincolnshire* may be considered a companion work to this, covering what has come to light since then. Although this work touches upon certain 'classic' mysteries, I have tried to largely focus on little-known stories, both historical and modern. Also included are instances of folklore not yet recorded that I have picked up over the years; but, more importantly, there are numerous supernatural and paranormal stories I have been told by the people of Lincolnshire, some of which (to the best of my knowledge) have also never been recorded.

Twenty-first-century Lincolnshire, it seems, is producing its own crop of urban legends, ghostly accounts and inexplicable paranormal phenomena.

Part I: The World of Ghosts, Spirits and Poltergeists

Introduction

To begin at the beginning, one of the earliest accounts of a ghostly apparition in Lincolnshire was published in 1679. A pamphlet, 'Strange and Wonderful News from Lincolnshire', explained how William Carter (who seems to have resided near Stamford) contrived to have his younger brother Thomas assassinated by three hitmen on the road to Cambridge, over a matter of inheritance. Following the funeral, at which William Carter shed 'many *crocodils* tears', the murdered youth's wraith appeared in his brother's yard, bleeding from pistol and rapier wounds. This apparition terrified Carter, and was apparently also seen by one of his servants, who leaked the information into the community, forcing Carter to reprimand his household over spreading rumours. Nonetheless, supernatural groaning and poltergeist activity thereafter bedeviled Carter's premises, with the hogs and horses permanently distressed. Carter's neighbours became increasingly aware something was wrong. In desperation, the household moved to another dwelling, but the ghost pursued them, 'and often changed itself into more fearful forms, as a bear, a lion, and the like with ghastly countenance, and horrid eyes, of sparkling fire, sometimes shrill shrieks, sometimes hollow groans...' A local conjurer was dragged into this situation to 'lay' the apparition, but the ghost of the murdered youth appeared on horseback before this third party, naming all those who had done him to death and demanding justice before vanishing. William Carter, by now a guilt-ridden nervous wreck, was brought before a magistrate and committed to Lincoln Gaol to await trial following a confession. His hired assassins immediately fled and could not be found. The truth of this incident was attested to by local 'men of good repute and fame', called George Smith, James Simson and Gregory Wilson. When the account was published Carter was still languishing in gaol, although one assumes he was subsequently hanged.

Stories of ghosts have haunted the imagination and tormented the logic of Lincolnshire folk for centuries. From the faithfully recorded haunting by 'Old Jeffrey' of the Wesley's parsonage house in Epworth during 1716–17 to the widely reported case of the 'bewitched' Walk Farm high on the Wolds at Binbrook in 1905, this county has never seen a generation where high-profile 'ghosts' were not claimed, witnessed, investigated, reported on and written about. In the 1990s, for instance, Lincolnshire produced a classic modern tale of ghostly terror in the 'Ruskington Horror'. This concerned a motorist who in 1998 contacted the daytime magazine show *This Morning* to recount how, one night two weeks

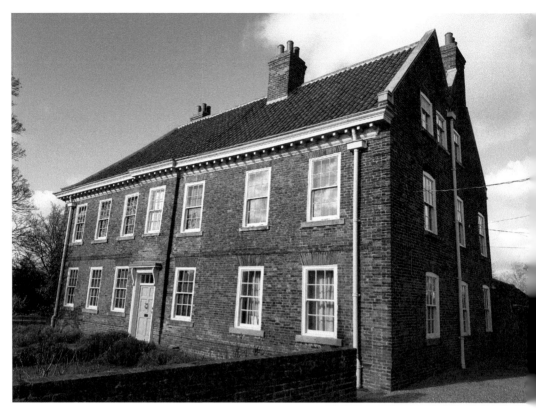

Above: Epworth Old Rectory, one of the region's most famously haunted houses.

Below: The A15 Ruskington turn-off.

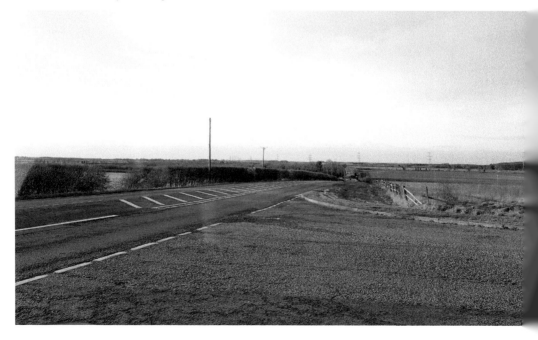

previously, a ghost had swept in front of his car on the A15 near the Ruskington turn-off. The witness described the apparition as materialising near the driver's side, having dark hair, 'olivey-green' skin, a pitted face and its left hand held up. It appeared distressed. The entity somehow remained in front of the windscreen for forty seconds despite the terrified driver not slowing down or stopping. His experience has become modern folklore, generating all sorts of legends about this stretch of the A15. (For example, this author's father, who soon afterwards worked as clerk for Ruskington Parish Council, was told the apparition was supposed to be the ghost of a farm labourer killed in a collision between Ruskington and Sleaford during a wartime blackout, who now haunted the area's roads 'trying to warn cars to slow down'.)

While a great many 'ghosts' may be examples of misreporting, misidentification or even outright fabrication, certain cases retain an eerie air of plausibility. Some experiences are never really fully explained and leave the witnesses involved genuinely believing they saw something supernatural. This author realised as much when compiling ghostly anecdotes for *Mysterious Lincolnshire*. Subsequent research has only reinforced the extent to which people claim to have knowledge of a ghost, or even to have experienced one first-hand.

There are, in fact, so many reports across the county of ghosts that one is tempted to believe there is something in it. Sightings continue to this day, and this chapter looks at some of Lincolnshire's lesser-known ghosts from the past, as well as new ghostly anecdotes that show how hauntings are a continuing phenomenon.

The Battle Without End

The Battle of Winceby on 11 October 1643 was a comparatively short one during England's Stuart-era civil wars, but nonetheless decisive for the Parliamentarians against the Royalists. Legends abound about this lethal skirmish across the empty countryside east of Horncastle: of how Oliver Cromwell providentially avoided being killed, and how Slash Lane earned its name from the carnage wrought upon the fleeing Royalists. One of the latter, Sir Ingram Hopton, is said to have had his head struck clean off in the melee, his horse thundering off and carrying the knight's headless cadaver to the Hopton front door at Horncastle.

According to a tradition recorded in the *Berwickshire Advertiser* (2 September 1879), on moonlit nights shadowy soldiers were to be seen in Slash Lane, lunging, parrying, mingling and separating. This spectacle had been witnessed by dozens at a time. An old labourer (a lifelong employee at Winceby Farm) stated that, when resting at noon in the battlefield, he had heard 'sounds of war issue, as it were, from the bowels of the earth; rumblings, rattlings, and something like the sound of galloping horses, as though the buried soldiers were fighting the battle over again underground'. He had never heard anything similar at any other place.

This site is haunted for other reasons. In a field beside Slash Lane there was once a gigantic boulder, and at some point in history a Winceby farmer, Dan Potter, tried to shift it in the hope of finding treasure beneath. Men, horses and chains were applied, and when the stone budged Potter cried out, 'Come God, come Devil, but we have it now!' As if in response, 'a horrid shag foal trotted through the gate', leapt onto the stone and yelled with such demonic fury that all present fled. The Shag-Foal was a

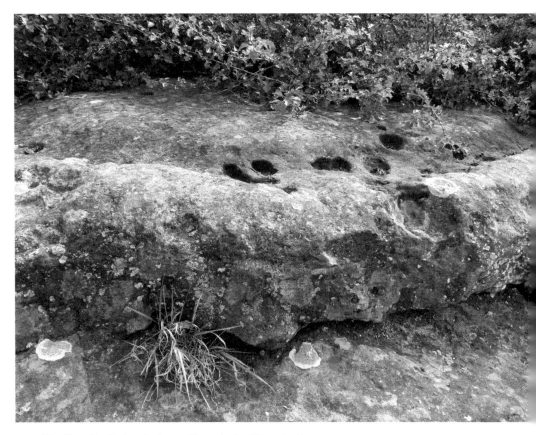

The Shag Foal's hoofprints still mark the Winceby Stone.

supernatural goblin, or demonic entity, that existed in the form of a rough-coated foal, and played perverse – sometimes lethal – tricks on lonely travellers. This story was told to a Mr Winn *c.* 1835, who later retold it in the *Lincolnshire Chronicle* (25 August 1885).

The great boulder for a long time became submerged in the field, until it was disinterred, with tremendous effort, in 1970 and hauled to the verge of Slash Lane. What are said to be the circular hoof prints of the Shag-Foal may yet be seen on its surface.

Spirits of the Humber

An article in the *Hull Packet* (15 May 1885) recorded an eerie belief that existed among those who lived along the Lincolnshire banks of the River Humber. When the moon was full at midnight on New Year's Eve, the spirits of all those drowned in the Humber over the centuries emerged from the water, and, after gazing about them in a bewildered fashion, turned their faces eastward. This army of ghosts – of every age, era and nation, and dressed in every variety of costume – then drifted out to sea, wailing terribly as they went.

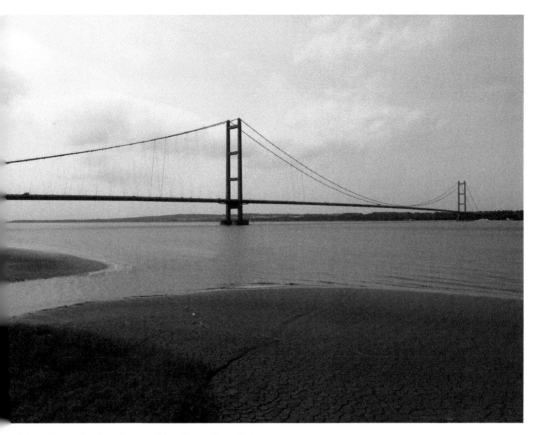

The River Humber, haunted by drowning victims.

The Haunted Farm of Halton Holegate

Eight years before the more famous events at Walk Farm, Binbrook, a haunting at a farmhouse in Halton Holegate near Spilsby also gained national attention. In 1897 the property, which stood some distance back from the high road, was tenanted by Mr and Mrs Wilson and their manservant.

Mrs Wilson told reporters that they had moved in on Lady Day (25 March), and on their first night were troubled by a mysterious knocking on the doors and walls. Further disturbances followed, including noises like 'someone was moving all the things about in a hurry downstairs', which prompted the servant to pack his bags and leave. That June, Mrs Wilson, from the foot of the stairs, saw an old, round-shouldered man stood on the landing looking down at her, and that same evening encountered the figure again in the bedroom before he vanished. She saw him several times after that, although not distinctly.

In inspecting an uneven portion of the sitting room's brick floor, the Wilsons discovered a quantity of bones, a gold ring and several pieces of black silk, all buried in quicklime. A surgeon, Dr Gay, who inspected the bones, announced them to be human remains around 100 years old, probably belonging to a woman.

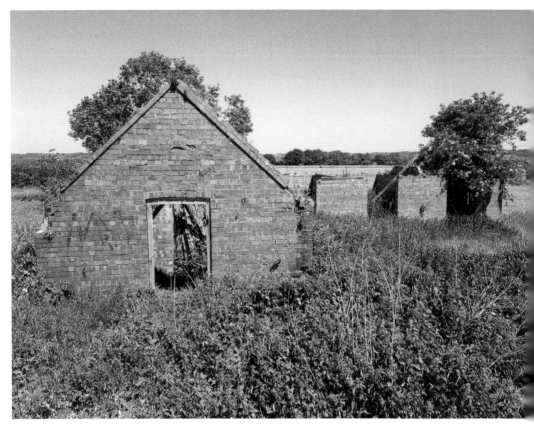

Remains of an outbuilding neighbouring High Farm. There are only the echoes of houses out here now.

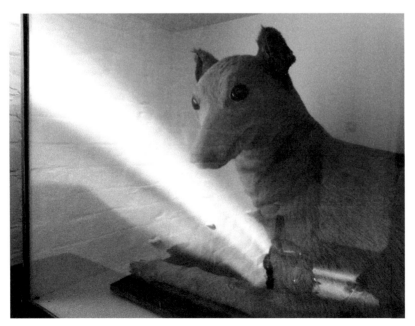

This whippet pined away following its master's execution at Lincoln Castle in 1877. The landlord of the Strugglers' Inn, Westgate, had it stuffed and mounted, and for some time after its ghost supposedly haunted the inn.

During these excavations, supernatural knocking and rapping bedevilled the farmhouse, although following the discoveries the mysterious old man stopped appearing.

Newspapers at the time suggested the house was 'known' to have been haunted for thirty years, and that rats had been ruled out as the source of the noises. James Hissey's *Over Fen and Wold* (1898) explains how, after the media frenzy had subsided, he visited the farm and found the tenants still troubled by the presence. The wife confirmed that the ghost she had seen was 'a little, bent old man with a wrinkled face'.

This haunted building is said to have been High Farm, a small two-storey, red-brick box-like structure situated in fields to the north-west of the village. I understand it burned down decades ago, an event said locally to have 'exorcised' the ghost. The farm was approached by a long driveway, still visible, but today, nothing remains on the site except a large pile of debris that includes some charred timbers.

Three Haunted Halls

Modern research into three historic halls traditionally haunted by ghostly apparitions has thrown up a mixed bag of results.

West of Lincoln is Doddington Hall, a three-storey, red-brick mansion begun in 1593 for Thomas Taylor, registrar to the Bishops of Lincoln. Built in the shape of the letter 'E', its many windows look out upon beautiful grounds and the wider Lincolnshire countryside. The hall is supposedly haunted by one of the county's most famous ghosts: the Brown Lady. This is an elderly woman wearing a stiff, old-fashioned long brown dress who materialises on a landing or else in a bedroom – supposedly in the presence of new brides at the hall. Her appearances last seconds, and she is said to smile benevolently, as though welcoming the new bride onto the premises.

This story seems to have become popularised in the late twentieth century, but when I contacted the hall asking for information I was told by the owner and chief executive, 'I am afraid I have no idea about this tradition and have never heard such a story. I have lived here happily, full time for many years and never seen or heard anything "weird", nor have my husband, children, visitors, guests or staff. There was a story about a lady who was chased by an unwanted suitor and jumped out of a window into a holly tree and escaped him. She survived and the bedroom was later named the Holly Bedroom.'

This second tradition is a genuine one, recorded in Cole's definitive *History of the Manor and Township of Doddington* (1897), his version differing only in that the lady leapt from the roof. However, an oft-repeated associated story, concerning a screaming wraith throwing itself off Doddington's roof as part of a spectral re-enactment, appears to be a misunderstanding. A novel called *Breezie Langton* (1869), by Hawley Smart, set at 'Dunnington Hall', which drew upon Doddington's folklore, has one character stating: 'Any night after twelve … you see the ghost of the girl, with her hair all flying loose, throw up her arms, and then with a shriek, spring through the window.' This creative license on Smart's part may now have accidentally become a 'true' ghost story attached to Doddington Hall.

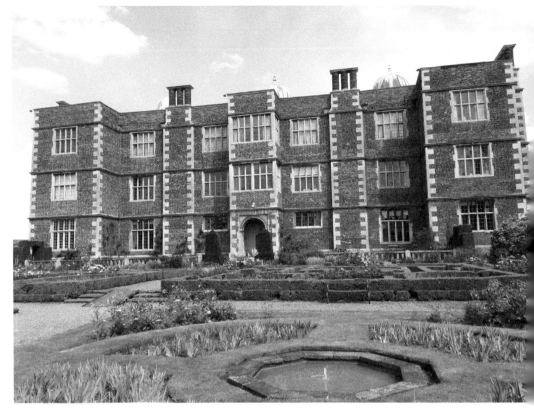

Doddington Hall.

Above left: A portrait of Sir John Bolle in Haugh's church, his place of interment.

Above right: Memorial to Sir John Bolle at Haugh's church.

If both of Doddington's famous ghosts lack substance, there is a third. Cole's *History* recorded the belief that the hall's second owner, Thomas Taylor the younger, who died suddenly of small pox, wandered the premises 'in anxiety' after death, looking for a chest of money. According to the *Echo* (12 April 1941), then-owners Major and Mrs Jarvis confirmed the Long Gallery – transformed into a ballroom in the late 1700s – was supposed to be haunted.

Next, one of Lincolnshire's oldest legends concerns the Green Lady of Thorpe Hall, South Elkington. In 1596 the hall's owner, Sir John Bolle, participated in the Anglo-Spanish War and was placed in charge of a wealthy and beautiful Spanish lady taken during the sacking of Cadiz. The woman – Donna Leonora Oviedo – became enamoured of the Englishman while in his care because of his gallantry, so much so that she proposed returning to England with him disguised as his page. However, Donna Leonora found Sir John remained faithful to his wife and so, heartbroken, took herself off to a nunnery: but not before sending her jewels and other items to her unconscious rival at Thorpe Hall in Lincolnshire, including her own portrait in which she wore green. According to Cayley Illingworth's *Scampton* (1810) the hall retained this portrait but it was destroyed around 1760.

By Illingworth's time, Thorpe Hall was supposed to be haunted by a spectral Green Lady who nightly appeared beneath (or among the branches of) a particular tree close to the mansion, and looked longingly at the building. This ghost was apparently seen around 1830, walking the hall's grounds at midnight, and in 1904 the *Lincolnshire Chronicle* reported her tragic lament could still be heard on the wind as it whistled between the trees surrounding the hall.

Donna Leonora's ghost was still being seen as late as the 1970s. Meg Wynne's *Ghosts and Legends Galore!* (1976) observed that 'some years ago' a maid had passed a mysterious lady in a green gown on the stairs, which she reported to the housekeeper; it was never ascertained who this lady was. Ms Wynne also noted that in the last six months the ghost had been spotted five times, mostly by 'reliable, middle-aged local people'. The increase in her appearances was linked to the fact the hall was at the time unoccupied.

Strangely, the Green Lady was also reported 30 miles away at Scampton. In the *Diocesan Magazine* (April 1939) Revd Johnson of Scotter wrote that a clerical friend of his had recently been driving through Scampton one dark, rainy night. Suddenly a lady dressed in a strange green evening dress appeared and stepped right in front of his car, forcing him to break to avoid a collision. When he exited the vehicle, the clergyman found no one there at all. As to why the Green Lady might drift about Scampton, Revd Johnson tenuously suggested it was because Sir John Bolle's brother, Sir George, occupied the Manor of Scampton.

Lastly, another enduring legend comes from Gainsborough Old Hall, the fifteenth-century manorial seat of the Burgh family situated by the Trent. According to Thomas Miller's *Our Old Town* (1857), there was the 'ghost story of a baron's daughter who was starved to death in the turret, and who, of course, "came again". Anybody about the hall would tell you of the young painter, who was at work inside, and who was picked up senseless, with the paint-brush in his hand, who for days after could only exclaim, "She is there! There she is!" And who, when he was restored, told a tale of the lady in white, who appeared to him and beckoned him to follow; smiling at first, then looking angry because he did not obey; then he knew no more.'

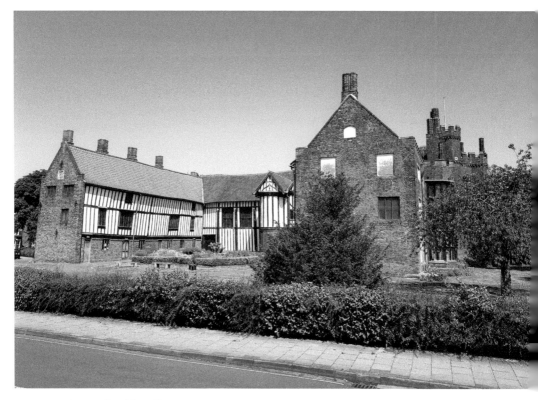

Gainsborough Old Hall.

The White Lady made her appearance at midday. Nowadays, a long corridor linking the rooms of the East Range has become known as 'the Ghost Corridor', due to the belief that she walks this part still, disappearing at a point in the wall where there was once a Tudor doorway.

She seems to have dimmed a bit, as she is now called the Grey Lady. However, her presence is still there, for the hall's visitor experience manager told me in 2019, 'Staff have said they have heard footsteps upstairs, thinking there is someone left in the building; when they go and check there is no one there.' I was also told that investigative paranormal teams always say they can sense 'something' within this ancient hall.

Lincolnshire's halls seem predominantly haunted by female spectres, rather than men, even the humbler among them. The ruins of the Elizabethan old hall at Northorpe, near Kirton-in-Lindsey, for example, were said in the nineteenth century to be haunted by the wraith of a woman in a stiff silk dress, called Mrs Slarum. Culverthorpe Hall, however, has an entirely different type of legend.

Culverthorpe Hall's Spectral Monkey

In Heydour's St Michael's Church, there is a marble monument to John, three-month-old son of Sir Michael Newton and Margaret, Countess of Coningsby. The infant died on 14 January 1733, supposedly snatched from his cradle by the family's pet monkey,

who took him upon the roof of Culverthorpe Hall (Newton's nearby residence) and threw him over the parapet to his death upon the steps. The monkey itself was afterwards destroyed and interred on an island in a lonely pool behind Culverthorpe Hall, the spot marked by a stone without inscription.

Trollope's *Sleaford* (1872) considered the tradition to be of 'reliable oral authority'. However, inspections of the parish register have suggested the infant in fact died in London, before being buried in Lincolnshire, it being unclear whether his death came by monkey attack at either location.

The hall and its grounds are haunted by a 'Blue Lady' who is apparently the grief-stricken ghost of John's mother, the Countess of Coningsby. (A white marble monument of the bereaved countess is also in Heydour's chapel.) More intriguingly, according to a local legend recorded in the *Grantham Journal* (5 August 1922), it was rumoured that sometimes at night a monkey's face appeared outside the porch glass, looking into Culverthorpe Hall, its primate features tortured with anguish and confusion.

A now weathered carving adorning the south porch of St Michael's Church, Coningsby, is supposedly a contemporary depiction of the Newton family's pet in the act of dropping the infant.

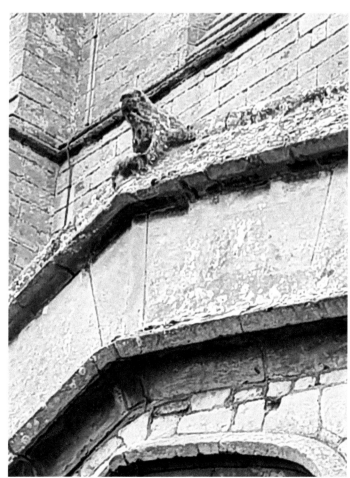

This weathered church carving is said to show the monkey about to drop the infant.

Indecipherable Messages at Daisy Hall

Situated in the flat, empty expanses north of Whaplode, Daisy Hall was an obvious candidate to be haunted. The house was inhabited by three elderly, eccentric brothers – George Henry, Ebenezer and Herbert Watkin – who in March 1937 told reporters about the weird supernatural events plaguing them.

The isolated house echoed with the usual poltergeist knocking and rapping. However, one day while sat down Ebenezer saw a weird flash of lightning, which focused, flickering, on a wall near him, and appeared to spell the phrase 'Expect a visitor' like an electric sign. The message flickered on and off several times before disappearing altogether. Soon afterwards, more flashes advertised different mystery words, which were barely readable but seemed to say: 'Cometh they *feerless*'.

A female visitor to Daisy Hall had previously observed something like a 'white sparrow' flitting around an upstairs room, which couldn't be found when searched for. By 20 March, the *Yorkshire Post* was reporting that the brothers had actually witnessed 'the ghostly vision of a bride in white', and heard ominous noises like the rolling of barrels. As a result, one of them was taken to hospital 'in a state of collapse'.

Old people in the district recalled hearing that in the early nineteenth century a man living at the house had murdered his new bride in a drunken rage, cramming the body into a cupboard space (which the brothers had only recently discovered and put to use) before fleeing Lincolnshire.

Today, Daisy Hall no longer exists, for it was torn down years ago, and what the reported phenomena stemmed from remains unknown.

'Old Harry'

In 2017 I was told a curious family anecdote by a life-long Lincolnite called Joan. Then into her eighties (and still working!), Joan recalled being told of a ghost in Lincoln when she was a little girl.

In the late 1940s Joan and her family lived in a house on Moorland Avenue, Boultham Moor. A neighbour of theirs called Harry, who lived three doors away, had been killed in 1944 at the Battle of Arnhem.

Joan's mother had, on several occasions while stood at the front door, said to her, 'Look, there's Old Harry again!' On the first occasion, when Joan asked what she meant, her mother told her that, if she cared to come and look, Harry's ghost could be seen crossing the road and walking up to his old front door!

Joan never dared to go and look herself, but recalls her mother saying, 'Don't be silly, come and look at him. He didn't hurt you when he was alive, so he won't hurt you now he's dead!' Apparently the wraith was not well defined, more of a misty human shape that moved up to a front door three houses away.

Although this occurred over seventy years ago now, Joan is adamant that her mother was not playing some kind of practical joke on her. The sightings were made on multiple occasions, when her mother was stood either at the front door or in the front room, looking out the window at Moorland Avenue. Joan was freely invited to come and look at 'Old Harry' but always refused, because she was too frightened. Joan tells me that, had I known her mother, this was simply not the type of joke she

would play, and has never believed anything other than that Harry's ghost must have been repeatedly returning to his beloved, familiar house – making the return journey as a ghost that he never managed in life.

The Man in the Snowstorm

One winter towards the end of the Second World War, a British bomber – badly shot up following a raid on Germany – crashed on Burton Fen while trying to make it back to RAF Scampton. Luckily, it had been snowing heavily, and this dampened the flames engulfing the crashed plane long enough for the weary crew to get out.

Setting off in what they hoped was the right direction to Scampton, it soon began to snow again. It being night-time, the survivors soon became hopelessly lost in a freezing blanket of white that had lost all its landmarks.

Suddenly one of the crew shouted out and pointed. Through the swirling snow was a barely visible figure, stood there and motioning that they should follow. Assuming him to be a local farmer, the crew struggled after him through the blizzard, at times almost waist high in drifting snow. The mysterious figure remained always just within their vision, the same distance ahead of them. After a long arduous trek uphill the snow began to die off, and all of a sudden the glare of headlights announced they had made it to a snow-cleared road (now the B1398), and salvation.

Their ordeal over, the crew desired to thank their rescuer and guide, but he was absolutely nowhere to be found. No one had seen him depart; in fact, no one had seen him closely, or even heard him speak. The deep snow had proved no obstacle to him in any way, leaving the crew to consider whether a ghost might have actually been their saviour.

This reminiscence was contributed to *Lincolnshire Life* (Autumn 1961) by Mrs K. Swindin.

Part of the featureless land between South Carlton and Burton Fen, which the airmen navigated with a 'ghost's' help.

Phantom Planes and Boats

On Wednesday 7 July 1954 the Skegness lifeboat was launched following a report that an unidentified aircraft had gone down in the sea off Vickers Point, Ingoldmells. Aircraft also joined the search, dropping flares over the water. The incident was reported in the *Lincolnshire Standard* (10 July 1954), yet no further information was forthcoming, either on a missing aircraft or any discoveries. Presumably the search proved fruitless and was concluded.

What makes this minor mystery more intriguing is that it was not the first such incident that year. In January, a report was received at Skegness lifeboat station that an RAF plane was suspected to have gone down in the Wash. However, the lifeboat's crew was subsequently stood down before launching. Then, in May, the Skegness lifeboat was again led to believe an RAF plane had crashed into the sea, forcing the crew to launch a search operation off the Lincolnshire coast while a Lincoln bomber and two Canadian jet fighters scoured the sea from above. No wreckage was found.

Aircraft nosediving into the sea are not an easy thing to misidentify, presumably. A hoaxer might be assumed to be behind these alleged sightings, except that in the May event, at least, the report came from a reputable source – the Inner Dowsing light vessel, which reported 'an explosion' 6 miles north-west of her position. With no explanation, is it just possible these sightings concerned phantom echoes of some wartime dogfight off the coast?

Similar mystery surrounds an enigmatic shipwreck observed in the choppy waters of the Humber on the evening of 14 September 1935. It was Captain Barrass of the river boat *Gainsborough Trader* who spotted the wreckage of a vessel, some 50 feet long, being churned up close to his own ship, before calling a crew member to come and see it also. He described it as 'an old wooden ship' that seemed to be rising up out of the water to display itself as 'practically a ship cut in two, and the full head turned over'.

A prolonged search of the Redcliff Channel found nothing, and Humber Conservancy officials said that even at low water, there was no wreck, new or old, in the locality. So from what dimension might this echo of the past have appeared?

Old Rainsforth's Grave

Around the mid-1700s Dickie Rainsforth, from East Ferry, earned a living skinning sheep and cattle carcasses on the once-extensive heathlands of Scotton Common. He had the idea of collecting toxic water from the hemp pits at Hardwick Hill, and feeding it to the livestock grazing on the common – hoping that by killing off these animals he'd keep himself in work. However, as the animals grew sick, the farmers guessed their water had been tampered with; and so Rainsforth, realising he was about to get caught, retreated to East Ferry where he hanged himself in a barn. As a suicide, he was buried at a local crossroads to confuse his ghost, should it attempt to rise.

The evidence supporting this well-known tradition is considerable. Local church registers suggest there was at least one Richard Rainsforth living at Ferry in the 1750s, and I understand from enquiries in Scotton that the descendants of Dickie Rainsforth are still living. Furthermore, the barn at East Ferry was owned by a Mr Ellis, who tradition says cut down Rainsforth's body. He supposedly kept the noose, and

Rainsforth's grave.

this grim keepsake was retained in his family until a granddaughter got rid of it, considering it unlucky. Some say the noose ended up in Scotton's church, but if so there is no sign of it today.

The track through Laughton Wood from Hardwick Farm leads to what decades ago would have been a crossroads, today called Rainford's Corner. Here can be sought out Dickie's featureless gravestone, now almost reclaimed by woodland vegetation. Until at least the early 1900s it was customary for travelers returning from Gainsborough to stop at the crossroads and drink to Dickie's health. By the 1970s it was said that if one stood on Dickie's grave at midnight, it would begin to tremble violently before his ghost appeared from the ground. Children apparently scoured Rainford's Corner looking for the apparition, enthralled by the notion of his restless spirit roaming the trees of Laughton Wood. In the village there is an allegation that Dickie Rainsforth's ghost was actually glimpsed around fifty years ago by more than one person.

Interestingly, Dickie's gravestone is not level, but lopsidedly sunken in the ground. It also has a crack in it. Could these features be evidence of its alleged 'trembling' after having been stood on at some point?

St Hugh's Head

On 15 April 1185 an earthquake split Lincoln Cathedral from top to bottom, and Hugh of Avalon, who was enthroned as bishop the following year, set about reconstructing and greatly enlarging the battered minster in the new Gothic style.

Hugh is arguably Lincoln's most famous bishop, a powerful and respected figure who was unafraid of the tempestuous monarchs of the day. Stories about him are legion, not least that of the famous swan of Stow, a huge bird that protected him like a guard dog and evidenced an almost supernatural devotion to him. After his death in 1200 in London, Hugh's coffin was carried into Lincoln by royalty to its place of interment within the cathedral.

Much of Lincoln Cathedral as we see it today was begun by Hugh of Avalon, and carried on by his successors and devotees, William de Blois, Hugh de Wells, and Bishop Grosseteste. Following Grosseteste's death in 1253, there next developed the Angel Choir and St Hugh's Shrine on the eastern side. This became necessary on account of the number of pilgrims who visited the cathedral after Hugh's canonisation in 1220. Around 1280, Hugh's remains were unearthed from their original burial place – today marked by a four-legged, seventeenth-century marble slab – and displayed for pilgrims.

Hugh's body was placed in a shrine that stood on the spot where he had been disinterred, while his head was enshrined as a separate attraction opposite, before the Burghersh tombs. Around 1364 thieves stole away St Hugh's head, stripping it of the jewels and precious things that decorated it, before throwing it in a nearby field. According to Henry Knyghton, a crow is said to have guarded the head until it was discovered and collected. The robbers sold their bounty in London for 20 marks, but upon returning to Lincoln they were themselves robbed, next confessing their own crime remorsefully before being imprisoned and hanged at Lincoln.

In 1540 Hugh's shrine was despoiled by Henry VIII's commissioners, and his remains disappeared to an unknown location, possibly the Tower of London. However, the great saint is still there in spirit: an ancient statue on the southernmost pinnacle of the West Front, reset in 1743, is traditionally said to represent Hugh blessing Lincolnshire.

Leaping forward many centuries, in March 1976 the *Lincolnshire Echo* published a story about a man who said he'd seen a human head rolling down the hill, away from Lincoln Cathedral. Upon which slope this dramatic sighting allegedly occurred was not recorded. Although Steep Hill and Pottergate are likely candidates, local tradition, in repeating this report, prefers Greestone Stairs as the location. In support of this,

St Hugh's original burial place in Lincoln Cathedral before his remains were put on display.

Greestone Stairs
postern gate.

such an unlikely 'haunting' would seem to have no other basis than a connection with the theft of Hugh's head, and Greestone Stairs would theoretically have been the quickest route for thieves wishing to exit the cathedral's defensive precinct.

This unusual legend certainly captured one person's imagination. Around ten years ago I met a man who told me that, in the early 2000s, he had lived uphill (Glebe Park), and every Sunday morning, in the small hours, he'd walk home from the city centre via Greestone Stairs. Often being tipsy, to amuse himself he'd regularly ask out loud at the postern gate for any ghosts to appear, to prove to himself such things existed. There are held to be multiple ghosts haunting Greestone Stairs, but he was particularly wary of the legendary 'rolling head' after hearing of it on the Ghost Walk. Urban legend now affirms this head is supposed to bowl people over or touch the backs of their legs on the steps.

My informant performed this ritual for months, but, of course, it never appeared. However, he has sworn to me that on one occasion, his vocal entreaties ('Hello, ghosts! If you're there then show yourself!') received a reply from the shadows further up the steps. An angry-sounding male voice cut through the silence, loudly saying, 'I'm here, move out of my way!'

This he assumes was some wag, out of sight, near the summit, replying to him, who had long since scarpered by the time he made it to the top.

The Ice-cold Hands, and Other Weird Grimsby Entities

In the mid-1990s, a young woman (Melanie) was living in a house on Eleanor Street, Grimsby. Then aged in her early twenties, she was laid in bed one night (alone), but was not yet asleep, having only just turned out the light.

There was no prior suggestion that her house was haunted, yet on this particular night Melanie suddenly felt the utterly terrifying sensation of the covers at the foot of her bed begin to move gently of their own accord. In her own words, this preceded

the feeling of hands working their way under the covers, which grabbed both of her feet before letting go and immediately withdrawing, accompanied by the rustle of the bedsheets.

In relating this story to me in June 2015, Melanie described the phantom hands as 'ice-cold, freezing', and she formed the impression that thereafter they had somehow slid underneath her bed. In her terror, she had snatched her knees up to her body and simply laid there in petrification for several minutes before finding the courage to get out of bed, switch the light on and look around the room.

She found nothing under the bed, or anywhere else in the room, to account for the creepy experience, which never again repeated itself after that one occasion.

Grimsby has a history of terrifying supernatural visitors invading the most mundane of residential properties. In 1959 the *People* carried a story about Inspector Beckett, who had gone to a house in Kirkstead Crescent where the occupants were complaining about a ghost. Intending to 'talk sense' to them, Beckett was astonished to see, while he was there, 'a dark shadow come down the stairs. I saw it for five or six seconds till it receded.'

In 1977 it was widely reported that the semi-detached council house of the Routledge family – husband John, wife Doreen and their four daughters aged between four and thirteen – was plagued by all manner of weird occurrences. The presence first manifested itself in 1975, rumpling bedclothes when the house was empty, but then progressed to other phenomena, such as moving items, hiding belongings, and disturbing the house with all manner of knockings and banging. Worse, ornaments were broken, a child's teddy bear was seen to jump between chairs in the living room, before later being found torn to shreds in a bedroom, and family members were pushed, kicked and hit by 'it' both in the house and garden. The entire household reportedly saw the entity, with twelve-year-old Carol describing it as 'black, with sort of spikes around its head, and it has red eyes'. Rooms would become chilly whenever it was near, and sometimes a terrible smell pervaded the air; its touch was described by Mrs Routledge as feeling like that of a dead person. A few days after the Routledges told their story, Revd Fred Grossmith, Minister of Calvary Church, performed an exorcism at the property on Caistor Drive.

In the mid-1980s another council house, on Langton Drive, was invaded by the shuffling figure of what appeared to be a hooded monk. It began in the front bedroom upstairs, when Sharon Grenny's little daughter Stacey complained that something 'with dishcloths over its face' was coming into the room at night and waking her up. Before long Sharon saw the entity herself, when it came into her own bedroom about 8.30 one evening, accompanied by a shuffling noise. The lights had gone out immediately beforehand, and when they came back on Sharon was confronted with a hooded entity, which bore no discernible features – no nose, eyes or hair – within its hood. It stood at the end of her bed, causing Sharon to react with such abject terror that she dashed past it and out of the room. Downstairs, it was only when her shock subsided that she realised with dawning horror she had left her little boy in the bedroom with the 'thing', since she had been putting him to bed in the room when the event occurred. She would only venture upstairs accompanied by a family friend to rescue the boy, although the entity had gone by then. By the time the matter was featured on *Arthur C. Clarke's World of Strange Powers* (1 May 1985), and the family interviewed, a sympathetic town council had already agreed to move them elsewhere.

Grimsby's Weelsby Street Elementary School today.

What links these last three examples is that they are all mere streets away from each other in the suburban Nunsthorpe area of south-western Grimsby. This author came across other accounts of a similar nature in this part of Grimsby (mentioned in *Mysterious Lincolnshire*), all being speculatively connected to the former Priory of St Leonard, which used to sit at Nun's Corner.

Staying in Grimsby, one other ghost scare was widely reported in September 1924. After a report that strange moaning had been heard emanating from the Weelsby Street Elementary School on the night of Sunday 7 September, the following night at midnight some 2,000 people surrounded the school, having to be prevented from accessing the premises by police. In the intervening twenty-four hours, rumours had swept Grimsby that a ghostly figure in white had been seen wandering the playground; mysterious lights had been seen floating between classrooms; a child's dismembered body had been found under the floor; and that someone had been discovered hanged in the belfry. (These last two aspects were false.) Various accounts had it the spook looked 'like a Frenchman' or 'a Russian wearing a black hat'.

The Figure in the Guildhall

Alongside the castle and cathedral, Lincoln's Stonebow arch is one of the city's landmarks. The arch dates to the late fifteenth century, replacing an earlier medieval version, which itself sat on the site of a third-century Roman gatehouse. The eastern

portion once functioned as a disgusting gaol before being rebuilt. The Stonebow is also famous for its collection of civic insignia, as well as the Guildhall and Council Chamber over the arch where Lincoln's civic business has historically been carried out.

It would be noteworthy if this building didn't have a ghost. In 2019 the mayor's officer explained to me, 'Regarding ghosts, I am here a lot, and I have never experienced anything, and I do have an open mind to this sort of thing! We have also had two paranormal evenings held here, both drew a blank.' However: 'In 1996 our Sheriff's Lady of the time and the Mayoress experienced seeing someone going down the stairs of the Guildhall.'

The figure seen in 1996 was female in form, but I take it to have been defined and wearing modernish clothes, since the Sheriff's Lady initially thought it was the mayoress going down the stairs towards the exit out onto Saltergate. It subsequently transpired that the mayoress was still on the premises, and she denied the person to have been herself. Therefore, the mysterious figure went unidentified. Several years previously, in the 1980s, a former mayor's officer is held to have heard footsteps running up the stairs, but discovered no one to account for the noise.

It would be fitting if the ghost was that of Maria Nevile, in 1925 Lincoln's first female mayor. Traditionally, the Guildhall is supposed to be haunted by Richard Mason, who was elected town clerk in 1826, but this seems not to have been the apparition seen on the stairs.

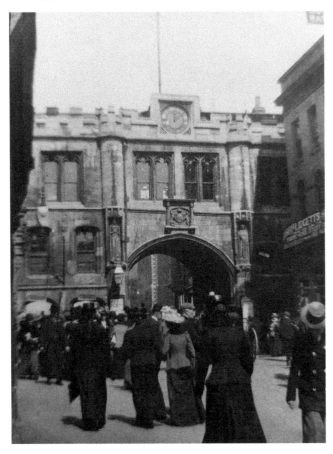

The Stonebow, *c.* 1900.

A Ghost in Eagle

There is a distinctly unlikely story as to how Eagle, close by Lincolnshire's border with Nottinghamshire, came by its name. In the days of Drake a mutinous seaman from Lincolnshire escaped captivity in Plymouth and ranged the countryside for years, always heading in the general direction of Lincoln. He committed several murders during his outlawry and was finally run to ground near All Saints Church at Eagle. His location was betrayed by a 'golden eagle' that harassed him while he attempted to hide in a tree, and he was killed during a final last stand with soldiers from the city. This, some say, was the reason why 'Eagle' became so named.

This information I was told around winter *c.* 2004 by a man named Scott, whose aunt lived in Eagle. Scott claimed that he was told the seaman had been called 'Charlie Murray' and that his ghost haunted all the roads around Eagle. Numerous people, he explained, had seen Murray's wraith at the roadside, a terrifying bald-headed apparition on account of its fearsome, aggressive appearance.

Scott next explained that he believed he may have seen Murray's ghost himself. His encounter had occurred *c.* 1998, when he had been visiting his aunt's house, which stood on High Street, near All Saints' Church. Sitting in the lounge, he had glanced towards the open kitchen door and seen within the kitchen what he at first took to be a hung sheet billowing with movement. Almost instantly, he realised this was no piece of laundry. As Scott looked harder the 'shape' took on the form of what seemed to be a powerfully built man striding through the kitchen.

The sighting lasted seconds. Scott darted into the kitchen but found the room empty, with nothing to account for the moving figure he had seen. In bringing the matter to his aunt's attention the story of Charlie Murray came up, and the experience evidently unnerved him enough for him to recall it some six years later in a general discussion about 'ghosts' with me.

Eagle's name, in fact, is a corruption of 'Aycle', Old English for 'Oak Wood'. The tale of Charlie Murray can be considered fiction, but not necessarily the ghost that now bears his name.

Phantom Airmen

A friend once explained to me that, in the 1980s, his cousin, Wayne, had seen a man dressed in the smart outfit of an RAF officer walking along Skellingthorpe Road, who reached the corner of Birchwood Avenue, Lincoln, before looking around confusedly and then disappearing. Although third hand, the anecdote is an interesting one, for this was approximately where RAF Skellingthorpe's officer's quarters were situated, thirty years before the Birchwood Housing Estate developed on the site.

This is not the only report of phantom RAF personnel I have been told; unnervingly, they have also been seen in people's houses. One case concerned a woman who had encountered 'an airman' in her house off Abingdon Avenue, Doddington Park, Lincoln, who simply faded away before her eyes. That was in the mid-1980s. Another case, ten years later, concerned a woman in her twenties who was staying at a house in Saltfleetby-St-Peter. On two occasions she awoke in the night to observe an RAF officer in full uniform, including hat, stood with his back to her simply staring silently out the bedroom window. Reasons for both hauntings were put forward: in the first

RAF Coleby Grange's derelict control tower. Most RAF bases in Lincolnshire have some sort of ghostly legend attached to them.

case, Doddington Park now covers part of the former RAF Skellingthorpe, adjoining Birchwood, and therefore, the airman had 'hung around'; in the second case, the witness was told by the house's owner that the previous occupants had had a son, who had been an airman. He had died young, killed in an accident.

Within a generation of the Second World War, Lincolnshire's airbases – many of which had become abandoned and left to the elements, their empty runways overlooked by eerily quiet control towers – were attracting legends of ghosts. According to *Folklore, Myths and Legends of Britain* (Reader's Digest, 1973), 'On a long-deserted Lincolnshire airfield the scream of rending metal is said to be that of a wartime bomber that crash-landed there with a dying crew.'

A persistent urban legend I have heard in Skellingthorpe over the last ten years is that of a 'phantom bomber' that passes north to south over the village, as though to the former airbase. Yet it is sound only: whenever people look up, they see nothing, and the sky remains empty.

Few remain who can directly remember the heroism and catastrophe that marked the lifetime of Lincolnshire's airbases, and many locations today fulfill other functions, or have fallen into disrepair. Even on a calm, clear day, there is something desolate and eerie about these long-abandoned places, as if it is just about possible to reach back in living memory and imagine them at the height of wartime activity. It is easy to see why most have earned reputations for being haunted. At former RAF Fiskerton, a poem inscribed on a memorial sums up the atmosphere:

> Stand by this stone and lend an ear,
> And I'll show you ghosts from yesteryear;
> The windsock's creak, the cold wind's moan,
> Long-dead men crowd round ... we're not alone.

Site of former RAF Fiskerton.

Thornton Abbey

The ruins of Thornton Abbey stand not far from the Humber, in the parish of Thornton Curtis. It was founded by William le Gros, Earl of Albemarle and Holderness, around 1139 for Augustinian canons. Originally a priory, it increased in importance until it became an abbey. Falling into abandonment in 1547, its remains are approached via an immense and ornate fortified gatehouse.

Sometime in the mid-1990s, 'Mel' had parked her car outside this very gatehouse, but not yet exited the vehicle. Her son, then a toddler, was with her, strapped in on the back seat. Ignition off, Mel was taking in the peaceful midday atmosphere when she began to feel like she was being watched. However, no one else was around and all was quiet.

Without warning, the car radio somehow suddenly blared into life, making Mel jump out her skin, and she had barely moved to turn the knob off before she noticed that a light was pinging on and off, which indicated one of the car's rear doors had been opened and closed – although she had heard no sound, perhaps on account of the blaring radio. Simultaneously, her son in the back began screaming in distress, and when Mel looked over her shoulder she saw he was looking not

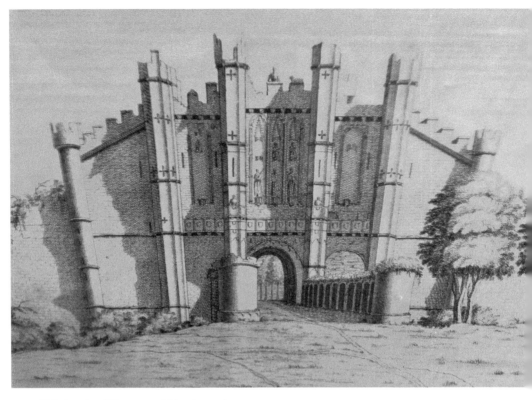

Old sketch of Thornton Abbey's gatehouse.

at her but in the direction of the gatehouse. Mel formed the immediate impression that 'something' had tried to get into the car by opening the back door, possibly to look at her son. Terrified, she turned the ignition, started the car and drove off, convinced as she did so that the same 'something' was watching her as the car skidded away. To this day she remains unapologetic and adamant she was not behaving irrationally, ascribing her actions to those of a mother merely wishing to protect her child from something paranormal at the abbey that she knew by instinct alone was interested in her visit. Reflecting, she described what was outside the car to me as 'an angry, evil presence'.

The Geography of England reported in 1744 of Thornton Abbey: 'In taking down an old wall not very long since, the workmen found the skeleton of a man, with a table, book, and candlestick, supposed to have been immured for some heinous crime.' The remains turned up near the chapter house. (Alternative accounts that the remains were found *c.* 1830 appear incorrect, unless the skeleton was simply left where it was for some time and then rediscovered.) Perhaps the remains belonged to the fourteenth abbot, Thomas Greetham, allegedly deposed and put to death around 1393.

In 1973 a photograph was taken that appeared to show a mysterious face in the chapter house ruins, and the abbey's gatehouse has for generations also been said to be haunted by Thomas Greetham's shadowy wraith. Could this have been what took such an interest in Mel's car? Greetham is said to have practiced the diabolical arts, and been a wicked man – perhaps that would explain the malevolence Mel sensed during her encounter.

The Green-faced Man

In Skellingthorpe, Jerusalem Road joins Old Chapel Road, and, until recently, there was a small piece of wasteland on this corner. In February 2011 a letter appeared in the local *Chatterbox* magazine from a woman who claimed her brother had been walking past this patch when someone suddenly materialised next to him. It was a man, wearing Victorian attire and with a greenish face. The startled witness said to him, 'Your face is quite green!' to which the strange Victorian man merely replied, 'Ah!' After that, the figure turned away and slowly disappeared.

Old Chapel Road in the nineteenth century led to a primitive Methodist chapel on Wood Bank, so perhaps the 'ghost' was something to do with that. As to why his face was green, who knows? Except to suggest that sickness and death was not uncommon in the parish at one time, owing to obnoxious ditches that ineffectually attempted to drain the waterlogged land near tenements. The woman who submitted the letter on her brother's behalf was simply left asking bemusedly: 'Do we have ghosts in Skellingthorpe?'

The Phantom Footprints

Staying in Skellingthorpe, another ghost apparently visited a property further along Jerusalem Road at the point where the houses begin to dwindle off and the parish becomes farmland and equine stables. Moreover, it seems to have left curious evidence of its appearance.

James moved into the bungalow in November 2010. Although the property dated to 1930, James, in relating his experience, was adamant there had never been any sensation of unease or oppression about the house – in fact, quite the opposite.

After around a year and a half James noticed something at his back door that he had never spotted before: the delicate outline of two feet, pressed into the concrete as though someone long ago had stood at the spot while it were still wet and new. The impressions, clearly visible where before there had been nothing, appeared to be those of a small-footed woman, judging from the size and the heel prints.

It is worth reiterating that James, in all his time at the bungalow on Jerusalem Road, had never noticed these imprints before, and when he pointed them out to his parents and girlfriend, all regular visitors, it became clear that not one of them had ever noticed them either!

The matter was somewhat strange, but soon rationalised. However, towards the end of 2012 James had an eerie experience that he felt to be somehow connected with the footmarks in the concrete at his back door. He was working in a back room at the time (during the day) when in his peripheral vision he saw a figure pass by the window outside.

So convinced was he that this was a real person calling on him that James actually left his desk and went to his back door to open it and greet the visitor. He had formed the impression that the person passing by his window was a woman, and supposed it was his girlfriend calling upon him unexpectedly. However, when he opened the back door no one was visible, although he had got there in mere seconds.

James next left his house (it was around 4 in the afternoon) and looked on his driveway and then along the road to see if someone had swiftly left his property, but there was no one anywhere.

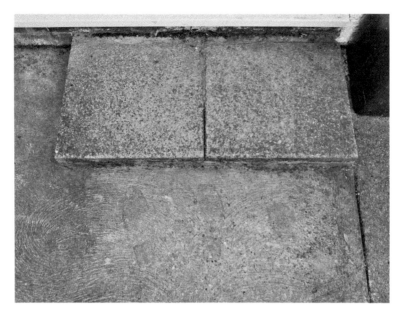

The footprints in the concrete, outlines just visible.

James believed that the person who passed by his window had a 'female appearance' and seemed to be walking up to his back door. However, there was a vagueness about her, silhouette-like, that James took at the time to be the result of his indirect view. However, he was certain that someone walked past his window that afternoon. What is curious is that this 'person' must have stopped at the exact spot where the footsteps were imprinted in the concrete, and because of this a connection was made in his mind.

James believed that – for the first time in his life – he may have actually seen a ghost, and considered it to be (perhaps) a former owner of the bungalow who loved the house so much that they just had to occasionally revisit it.

Haunted Hostelries

An information board outside the Witch and Wardrobe, Lincoln, advertises: 'During restoration work in the 1970s, an original 17th century wooden spiral staircase was discovered hidden behind false walls. This is situated to the west side of the bar. Myth leads us to believe that an old lady fell down the stairs, broke her neck and died. She now haunts the Witch and Wardrobe – but who knows?'

Like this place, dozens of pubs across Lincolnshire have their resident ghost, which is often part of the establishment's very identity, and a frequent talking point for regulars.

For example, Mrs A. Meacock, a former patron of the Lord Nelson (or 'Nellie') pub on Market Rasen Road, Dunholme, learned several years ago that the place was supposedly inhabited 'by an old lady ghost'. Her opinion on the matter to me was, 'She mostly just floated about the place, but a lot of people saw her, apparently, because she'd been there since forever. Mind you, all the old coaching inns around here are bound to be haunted, aren't they? And now that the Nellie is a Co-op then it'll be interesting to see what "she" does next, won't it.'

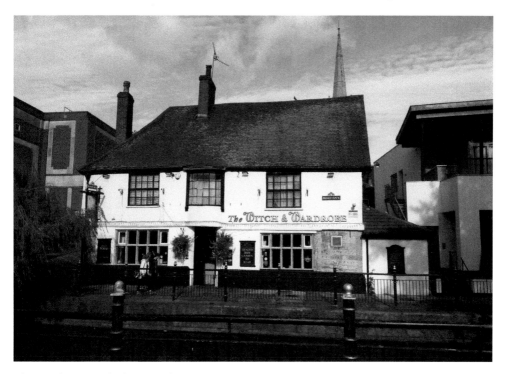

The Witch & Wardrobe, Lincoln.

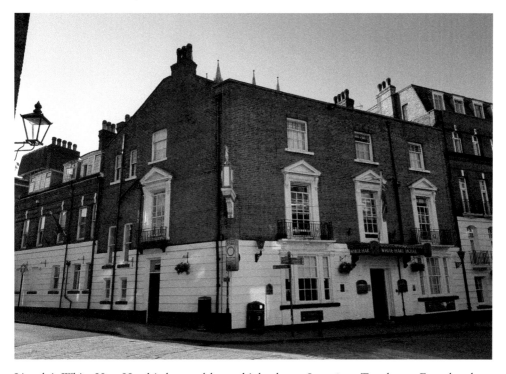

Lincoln's White Hart Hotel is haunted by multiple ghosts. In 1984 a Trusthouse Forte brochure referenced 'a strange fat man who appears, wringing his hands, and asking about his lost ginger jar'.

The Black Bull, long part of Welton's fabric, is a good representative example of a typical haunted Lincolnshire pub. An old coaching inn, during the early 1800s auctions and coroner's inquests were held there, and in the 1940s it was a hangout for those stationed at nearby RAF Dunholme Lodge and RAF Scampton.

There have long been stories about the Bull being haunted. Back in the early 1970s, when the pub was run by Mr and Mrs Price, numerous ghostly occurrences were catalogued within their first eighteen months. One allegation came from a visitor staying overnight in the Scampton Lounge, who complained of phantom children running in and out of the room all night. Poltergeist activity was also reported. The main door, after being locked and bolted, was found wide open; three beer bottles were whisked off a shelf and smashed on the floor; and a posy bowl jumped off a shelf and touched the ceiling before setting itself down again. (This last example happened before an independent witness.) Weirdly, after the public bar was cleaned, something scattered beermats around the floor and filled empty ashtrays with used cigarette butts while the owners were out of the room. Mrs Price believed she had seen the main culprit, for the door to her room had opened, and for a brief moment she glimpsed a man wearing a wartime flying jacket. In 1971, Bill Dales, an interested sceptic from Bracebridge Heath, and a friend stayed overnight, and managed to catch on tape the sound of footsteps clumping up the eighteen steps to the restaurant, followed by a door clicking shut. Mr Dales was adamant the recording was 'not a stunt', according to a report in the *Sunday Express*. (The upstairs restaurant is currently unused.)

Strange events continue to this day. Towards the end of September 2014 one of the Bull's landlords was on the premises during the day, accompanied by the pub's

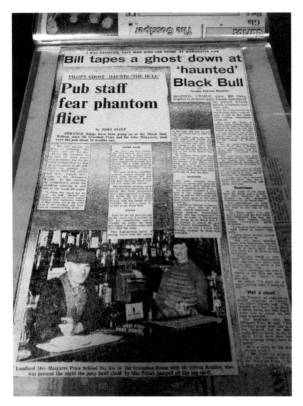

The Black Bull at Welton keeps a scrapbook containing clippings about its haunting.

accountant. Both swear that on at least three separate occasions, separated by a minute or two, a hand dryer was activated as though someone was in the toilets drying their hands. In fact, they became convinced someone was moving around in there – so much so that one of the men interrupted their meeting to go and investigate, only to find the room, including the cubicle, entirely empty. The hand dryer was not habitually malfunctioning, either; in fact, it had never started working by itself before, and – apart from that one time – hasn't done so since.

In December 2018, a long-time resident of Welton, and a regular at the Black Bull, reiterated to me that the 'ghost' was still believed to be that of an airman connected in some way with RAF Dunholme Lodge, which ceased activity in 1964.

The Figure in the Cellar

In the early 1990s Claire, then in her early twenties, was working behind the bar at the Constitutional Club – a striking, red-brick, Victorian-era venue on Lincoln's Broadgate – when she had a very strange experience.

It was the start of the working day. After descending a staircase to check the barrels, immediately upon entering the cellar Claire encountered a man in the gloom who wore a tank top and flat cap, and simply passed by her soundlessly, departing the cellar as she went in.

Lincoln's Constitutional Club.

Claire thought no more of it, assuming she had seen another staff member, until she was told that the person she thought it was had gone on holiday (abroad) earlier that week. In a general discussion that followed, it was established there was no one on the premises who fitted the description of the man Claire had passed, and it was left for one long-standing staff member to suggest the figure reminded him of a previous owner, who had died a decade or so earlier.

Claire herself had been observed setting off down the staircase by other staff, who confirmed no other person had emerged from the cellar until she herself returned. In Claire's own words, 'It sent a cold shock down my spine when it was suggested that I must have seen a ghost, but it certainly wasn't threatening in any way. He just walked past me as I walked into the cellar. That was the one and only time I saw him. Perhaps he loved the place so much he didn't want to leave, but that's as much as there is to it.'

The Mystery Figure in a Government Building

The strange experience of Tony, a driver-handyman at Ceres House on the northern outskirts of Lincoln, indicates that even the erection of a modern building cannot stop the passage of ghosts.

Ceres House is a relatively young building, opened in 1977 by a government minister. These days the large open-plan room on the ground floor that looks out onto Nettleham Road is occupied by civil servants, but in the mid-1980s that large room was an all-purpose filing room stacked with documents and records.

Tony had retreated to the solitude of this room one day for a quiet cup of tea. It was fairly early in the morning and he settled himself in a chair with his feet up on an empty desk, pouring his tea from out of a flask.

Tony's reverie was interrupted by a curious white misty shape that materialised over by the southern corner wall, for all intents and purposes appearing in the room as if it had simply emerged through the wall from outside. This form, walking in a human like manner, moved across the carpet, and, as Tony watched, it was twice briefly obscured by the pillars that lined the centre of the room. The incident lasted about 20 seconds before Tony lost sight of the apparition from his vantage point.

Recovering from his astonishment, Tony leapt out his chair and rushed to the area of the room where he had last been able to view the shape. It was no longer visible, presumably having traversed the room and vanished through the opposite wall. The temperature at the spot where Tony now stood was extremely chilly, in contrast to the spot where moments before he had sat with his tea.

Tony was adamant that what he had seen was the shade of a human being, but so misty and ill-defined that it had been impossible to make out any details – even as to whether it was male or female. However, Tony had certainly seen something, and he immediately raced to get one of the managers to report the incident. Taking her to the room, she too felt how the air became strangely chilly at the point where the apparition had made its way.

Tony, in all the years I knew him, never elaborated on this story, which he told me in 1998, and continued to insist he was sure of nothing other than that the form had been that of a human being. The ghost only put in that one appearance,

The mysterious figure appeared where the cabinets are and moved through the room, left to right.

although it became very well known to staff at Ceres House in the following years. Tony himself retired *c.* 2006, but the story of his encounter remained as a kind of urban legend within the building, with the cleaners at the place being reluctant to discuss the ghost because it gave one of them 'the willies'. Theories developed as to who the ghost might have been. An employee was understood to have died on the first floor, and apparently the cleaners thought this a likely explanation. It was also suggested that Tony's ghost might be that of a Roman soldier, although this is certainly not how he explained his experience to me. I'm not sure where the 'Roman soldier' theory originated from, other than to suggest that Lincoln is a Roman town and over time staff may have wished to impose an identity onto their ghost.

'Smokey Joe'

Elsewhere in Lincoln, at the time of writing the offices of the National Probation Service are on Lindum Terrace, situated in one of the large, grey-brick, mid-nineteenth-century properties that line this road. It supposedly has a peculiar type of haunting, one that seems to have become more noticeable ever since the smoking bans were enforced in public places in the early 2000s in England.

One upper room, used as the conference room, is known to exude a very strong smell of cigarette smoke, as Nicola – who worked there in 2009–10 – experienced. She recalls that on one occasion, when she had not been employed there long, she unlocked the door to the conference room one morning (to set the room up) and found it heavy with the unmistakable scent of cigarette smoke. As she explained to me in August 2015: 'It was really quite phenomenal. It (the smell) hung thick in the air in the middle of the room, and try as I might I could not find where it was coming from. The windows were closed, the heating was not on, there were no vents it was coming in through – it simply hung in the air like someone was stood there having a cigarette. You could almost walk around it – from clean air and into what I'd call a cloud of cigarette smoke, except that nothing was visible in the air. No wisps of smoke, nothing like that.' In fact, she was initially annoyed, because she thought she was being asked to set the room up after someone had just put a cigarette out in there, with no regard to its making her hair and clothes smell.

Puzzled, Nicola was positively amazed when a fellow employee explained how that particular room was known to harbour a 'ghost' that had been nicknamed 'Smokey Joe' – on account of the fact that others had experienced the sensation themselves in the past.

As for an explanation, there hasn't yet been one forthcoming. The building didn't have much of a history, so it was left for the employees to speculate that 'Smokey Joe' had been a Victorian 'someone' who formerly lived at the property when it had been a house, and had liked to indulge in a cigarette.

Local Government Ghosts

Lately, there are stories emerging of the local government buildings in central Lincoln being haunted. The organisation layout here is called 'the campus', and it is made up of multiple council buildings of various ages between Newland and West Parade. At its core is a remnant portion of a desirable late Georgian residence, Newland House, which developed into County Offices.

One of the modern (1982) buildings, Orchard House, has a 'haunted basement room' (aptly, room 13), which is said to have a poltergeist. The room has no permanent staff, but in the autumn of 2018 two workers making use of a desk in there heard a tremendous crash behind them, as if a heavy box full of files had been hurled from a top shelf onto the floor at the back of the room. However, they found no spillage or accident to account for the noise, which they were convinced had come from within the room. Room 13 is at the end of a long, silent corridor below ground level, and on another occasion a worker is said to have been passing by when they heard noises from inside the room, as if things were being moved around, despite the door being locked and the lights off within.

Fronting onto Newland is a row of former houses used by the council as offices, one of which on the ground floor has a phantom that apparently picks up and shuffles paper. It has been heard doing this from the next-door room, but the suspect room is always found undisturbed and empty when investigated. On one occasion, a staff member claims to have been in this room when he heard three knocks upon the door to outside, as though someone wished to be let in. Of course, there was no one waiting when he opened the door to admit the visitor.

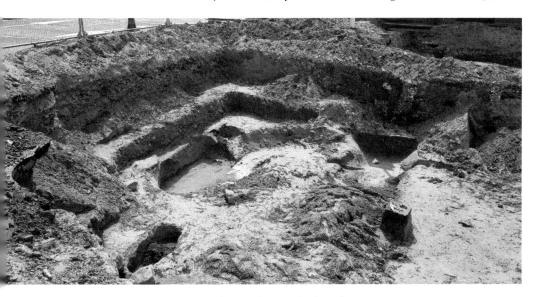

Ancient graves discovered and excavated near the Brayford Pool in 2019.

More than once mysterious footsteps have also been heard clumping overhead on the first floor above the suspect room. As one witness put it, 'I was the only one in the building at the time, and was stood in the stairwell. There was clearly someone on the first floor walking around in the room over my head. There was no mistaking the thump of the footfalls. You could actually trace the path they were walking.'

In July 2020, the offices were naturally virtually empty during the coronavirus pandemic, except for a skeleton staff. Yet one employee has sworn to me that she heard her name spoken near her, despite being alone on the premises at the time. A second employee – again alone on the premises in January 2021 – clearly heard a female voice say 'Hello!' to her from a specific point in a doorway. Oddly, this was the same spot where the first witness had heard her name spoken, and at the same time of day, 07.50a.m. Staff are currently considering a name for their unknown guest.

In general discussion with the staff, it has been said to me, 'These buildings used to be houses, and perhaps the people who lived here still live here!' However, in June 2019 I heard another staff member's explanation that all hauntings are something to do with a Roman-era graveyard that stretched from the Brayford Pool to Newland, which has on multiple occasions been disturbed and excavated.

Site of the Old Asylum

If one follows the A15 road south out of Lincoln, a sharp hill takes them quickly through the village of Bracebridge Heath.

Here, largely screened from the A15 by trees, are the remains of the Lincolnshire County Lunatic Asylum, a nineteenth-century hospital complex later going by the name St John's. After closing in 1989 it became the very definition of an abandoned site, complete with scowling, cavernous buildings that local people living on the new housing estate nearby grew cautious of whenever they walked past them. This author's parents lived on Norwich Drive in the early 1990s, and a friend of theirs

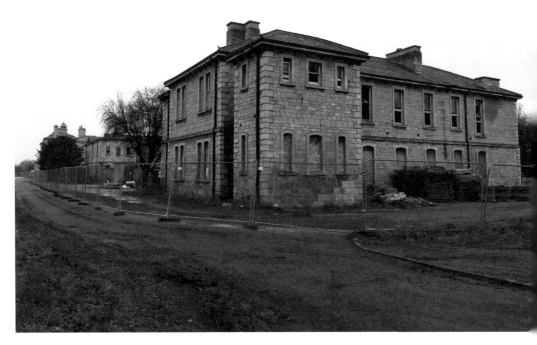

Part of the shell of the old asylum.

in the fire brigade, Derek, once told them that fire crews were regularly called out to the main body of the asylum complex, approached via Caistor Road. This was because concerned residents had reported 'small fires' to be visible through the large rectangular Italianate windows. Not once were there ever any fires to put out.

Possibly connected in some way are the experiences of a couple who rented a two-bedroom semi on Gloucester Close, in the eastern part of the housing estate, during late 2014 and early 2015. Their house was relatively new, yet, according to the two witnesses, it harboured an incredibly oppressive atmosphere, as if its walls were saturated with unhappiness permanently. According to one of them, it was the 'worst house I've ever lived in, there was clearly something not right with it'. The disturbances, when they began, originally took something of a traditional form: for example, when the couple were downstairs, they could hear footsteps clumping about the rooms over their heads; when they were upstairs, they could clearly hear things being moved around below them. When they investigated, nothing was ever found suggesting anything untoward.

On one occasion, the couple retired to bed and switched the main living room light off, an action that required the physical turning of a dimmer switch until it clicked 'off'. Five minutes later, when they turned the upstairs light off they discovered that the living room light was still fully on downstairs. This is the kind of puerile trick that poltergeists seem to delight in, but perhaps the most unnerving incident occurred when the lady of the house slept downstairs one night, laid out on the sofa next to a coffee table.

She had barely turned the light out, and was a long way from being asleep, when a gigantic 'bang' sounded immediately next to her ear. The sound was as if someone

had slammed the flat of their hand down on the coffee table near her head, and this impression was reinforced by the fact that the witness actually felt the air move near her face immediately prior to the noise. This incident so terrified her that she immediately ran upstairs to the bedroom.

This latter phenomenon appeared particularly disturbing in that the entity – whatever it was – seemed to be trying to 'communicate' with them in the only manner it was capable of. In the spring of 2015 the couple upped and left to live in Welton, a curious comment made by their landlady echoing in their ears. This was to the effect that 'no one ever stays in that house longer than six months ...'

As for an explanation, it was suggested to me by these two witnesses that the presence in the house might be something to do with the old asylum. They speculated it may have stemmed from someone being buried in the ground at the spot decades before Gloucester Close existed, who now didn't realise where they were, and had become hopelessly lost in some kind of supernatural limbo.

Further along the Sleaford Road is a street called Broadway, and in 2019 a resident here explained to me that her property had definitely been haunted in the recent past. It had begun around 2004 with the family's young son, who was repeatedly terrified by the sight of an out-of-place man he saw in various parts of the house. Only the child saw this person until his father eventually caught a glimpse of a 'man wearing strange clothes' in the house. The family later discovered that around the same time a friend living nearby had seen, very clearly, 'a man dressed in red velvet' who had come into the bedroom and sat down on the end of her bed. When descriptions were compared, it became apparent this was the same figure seen in both houses, despite them being about a mile distant.

The unnerving thing about this was that the friend had lived on Gloucester Close – the same street where the aforementioned 2015 witnesses later lived. Therefore, is it possible the 'man in red velvet' wanders Bracebridge Heath, invading any house seemingly at random?

The Little Girl of 'Hospital Cottages'

Lately, there are rumours of another haunting in Bracebridge Heath. There is a row of Victorian tenements – known as 'the Hospital Cottages' – on the east side of the Sleaford Road, which (I am told) at one time facilitated the asylum staff. Quite recently two of the houses, next door to each other, were purchased by a husband and wife, with the husband occupying one and the wife living in the other. However, after a short time both parties unexpectedly and simultaneously put their respective properties on the market. This was because they had both witnessed the ghost of 'a little girl' appearing and disappearing through the wall dividing the two properties.

Disturbingly, when outside, one of the witnesses involved had even looked at a particular window and seen this little child indoors, looking back at them.

This tale came my way during Branston's Christmas market event in early December 2013, via the father of one of the witnesses. Why the child would pass between both houses was something of a mystery as there is no suggestion the two premises had ever formed a single dwelling. Therefore, could it be that it was not the properties the apparition was interested in; rather, the couple themselves?

Humphrey the Poltergeist

'Humphrey', the resident poltergeist at Browns Pie Shop on Steep Hill, Lincoln, is rapidly becoming the city's best-known ghost.

Situated in a building dating to the seventeenth century, Browns has for years been plagued by a mischievous spirit that moves – and occasionally throws – things around in the usual attention-seeking manner of such entities. It is not known why 'it' is called 'Humphrey', other than that in the past the head chef felt obliged to give the presence a name. One commonly-repeated story concerns this head chef, who in the early 1990s used to greet 'Humphrey' loudly every day, in the belief it placated the spirit. When the chef couldn't get in one day, an emergency replacement (the proprietor) failed to follow this tradition. He subsequently discovered 'Humphrey' had thrown a large cook's knife off a bench and into the floor, blade first, while he was briefly out the kitchen. (I understand that the tradition of calling 'Hello Humphrey' each morning is still practiced these days, although less religiously than it used to be.)

On 13 February 2019 I visited Browns Pie Shop to enjoy the food and make enquiries. 'Humphrey', it seems, is still very much a presence. A waitress explained to me that she had, on one occasion, set the tables in the basement room ready for customers arriving. The tables were set in a particular manner, and after leaving briefly she returned to discover that on every table all the knives and forks had been swapped over. She also claimed to have seen napkins fly across the room. Furthermore, I was told that a customer had once – upon learning of Humphrey – commented, 'That must have been what threw that salt pot at me!'

Again in the basement room, one waitress was chastised for not setting out the napkins. She protested she had done. A few weeks later a terrible smell pervaded the room, and when a ventilation duct was searched it was found stuffed full of the missing napkins, with everyone at a loss to explain how – and why – they had ended up there.

There is a developing suggestion that the poltergeist is linked to a mysterious little boy, aged around eight and wearing Victorian-type clothes, who has been glimpsed on the premises. Very clear giggling, like that of a child, has been heard coming from empty rooms. Rather more unnervingly, I was also told that Browns' current owner had sometimes taken a break from doing the books in an upstairs room, only to find her infant son laughing and playing with someone, whom her son could obviously see – but she couldn't. This had happened more than once, frightening the owner enough each time for her to pick up her son and take him out the room.

This reinforces the theory that 'Humphrey' is, indeed, the ghost of a child trying to make friends. I was told that he is supposed, in life, to have been a little boy who died after falling down the cellar stairs when Browns was the Fox & Hounds tavern. Eerily, on the premises there is a large, framed black and white photograph of the Fox & Hounds as it was *c.* 1900, complete with Victorian urchins in the street and the backdrop of Steep Hill. In the upper window of the Fox & Hounds, looking directly at the photographer, there can be seen on his own a sad-looking little boy.

This, I was told, was 'Humphrey' of Browns Pie Shop: 'People who think they have seen the ghost out the corner of their eye say he looks just like that little boy in the photo.'

Browns Pie Shop.

The Disturbed Builder

In 2014 I was told that renovation work at a house on Lincoln's Brant Road had prompted a haunting that June.

It began with two builders working on a new upstairs room, who experienced a persistent sensation of being watched, before subsequently glimpsing a figure on the landing. It being daytime, and they being the only people on the property, the pair began searching the premises, unsure whether there was an intruder. Looking in the direction of an upstairs room both saw a small figure – about 4 feet tall or so, with 'big eyes' – peering at them. It appeared to be hiding behind the door, its face partially obscured behind two small hands, which grasped the door's edge. In their terrified disbelief they registered not whether it was a man, woman or child they were looking at; merely that they were staring at something and it was looking right back at them. It ducked out of sight behind the door after a moment, and could not be discovered when the two men finally found the courage to enter the room themselves.

In the aftermath of this incident, when it was discussed, the house's owner claimed to have seen in his peripheral vision 'someone small' rushing past him once or twice on certain mornings. The owner – a man from a building background – understood that a previous owner (deceased) had not only been a builder himself but also a man of short stature. Furthermore, the owner professed to know that 'dead builders don't like other builders working on their house'.

This theory explained why a decorator, subsequently working on his own upstairs, and knowing of the sightings, was not troubled by the entity. The decorator concerned

passed the story to me, and in June 2015 provided an update. He reiterated the story was not a hoax, and the two builders had been genuinely frightened. Apparently, the house had achieved something of a degree of notoriety in the year-long interim, it becoming the case that 'everybody knows' it had a ghost. It was even being said that another ghost – believed to be that of the small man's wife – had been witnessed since then. She had also appeared in broad daylight, giving the impression when seen that she was 'standing behind a net curtain'.

The Phantom Horse

Just over the county border in Rutland, one of Stocken Hall's eighteenth-century tenants was General Grosvenor.

The general's favourite horse, Black Butcher, fell dead underneath him on Stone Drive in Morkery Wood, which is on the Lincolnshire side. The animal was buried on the spot and Grosvenor erected a small obelisk there, carved on one side with a portrait of the horse. The other side bore a poem celebrating the horse's qualities. This inscription is now much weathered, but once included the lines:

> Pass ye not heedless by this pile of stones
> For underneath lie honest Butcher's bones.

I have heard it said that Black Butcher's ghost haunts the obelisk. Stone Drive is a favourite place for dog walkers, and around five years ago I was told by one of them

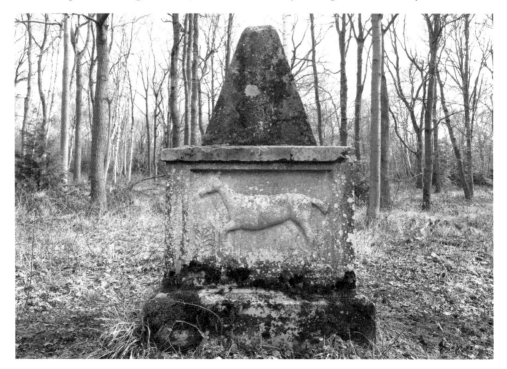

Black Butcher's obelisk.

that their pet regularly 'acted up' near the obelisk, pricking its ears up, barking and straining, as though it could sense another animal in the trees there. Apparently, 'other dog owners have reported the same thing'.

Tradition tells us the horse's ghost materialises and then gallops towards Stocken Hall, although for some reason the apparition seems to be white.

Haunted Branston

Between 1680 and 1891, six successive members of the Curtois family were rectors of Branston, east of Lincoln. Their residence was the rectory, built in 1765 on Church Hill, and the building has long been said to be haunted by the ghost of one or more of the rectors. Renamed Hainton House, a few years ago it was sold as seven elegant apartments, but in the village there is a story that it took a long time to sell them because of its reputation. According to one village resident, 'Faces were seen at the windows looking out when the place was supposed to be empty.'

Elsewhere, Branston Hall, set in 88 acres of its own parkland off Lincoln Road, is haunted by a multitude of apparitions. This Victorian-era country house, which replaced an older, nearby hall destroyed by fire, reportedly has a lounge from which 1920s jazz music can be heard emanating; but by the time the lounge is entered, the echoes of the music have already faded away. A staff member at the hall confirmed to me, 'It is true. We have had numerous reports by staff over the years, ranging from two young girls giggling in the cellars to an old grey lady who floats slowly down the stairs. I can also confirm numerous staff members are reported to have seen/heard these apparitions and we have even had staff unwilling to enter certain locations in the hotel because of it. I don't believe any events have been held in the past, but I have no doubt activity would be found.'

In 2020, I was told by residents living on Lincoln Road of a mystery related to a house where a recent double murder had occurred. The premises, at the time empty,

Hainton House, Branston.

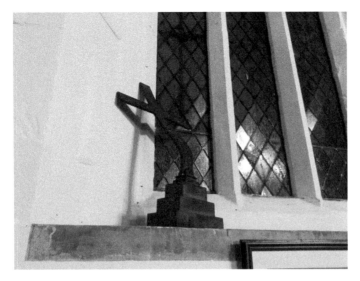

Memorials to the Curtois family can be found in Branston's church. So too this iron cross, warped when the building caught fire on Christmas Day 1962.

were inaccessible because locked iron gates secured it. Yet an intruder alarm was regularly heard to go off within, and one resident living opposite the house stated to me, 'There's no explanation for it. It's actually quite concerning why it keeps going off. No one can get onto the property from outside, so what's causing it is a mystery.'

The Ongoing Mystery

A friend of mine, who in 2015 started work at St Luke's Nursing Home on Main Street, Scothern, had not been there longer than a week before she learned: 'They say it used to be a boys' home before. Some staff have seen small figures running around corridors, out the corner of their eye.' St Luke's, in a former life, was indeed a workhouse and boys' home, around the beginning of the twentieth century.

This is just one example of new ghost mysteries that are emerging all the time. In May 2019 a rambler told me a story of something weird she had experienced at a Roman-era tumulus situated dramatically on a windswept hill north of Riseholme College. She had been at the mound early one evening, photographing it and enjoying the stillness, when, as she left, she clearly heard a woman or young girl laughing and giggling near to her. Thinking she was not alone, she looked about for the source of the laughter, which could not be found, and as she walked away, entertained the creepy feeling that 'someone' was at the mound watching her, although no one was to be seen. This witness pondered, 'I wonder if there was a princess buried in the mound, not a king or warrior!'

I am also told that, three or four years ago, a staff member unlocked the front door to Bunty's Tea Room on Steep Hill, Lincoln, one morning and found a small golden key on the floor in front of her. It hadn't been there the night before; where it came from, and, more intriguingly, what it unlocked remained a mystery.

Local newspapers continue to find good copy in new ghost stories. In 2006 alone, the *Louth Leader* reported on poltergeist activity linked to a 'mysterious pixie-featured man' at Mablethorpe's Red Doors Market on High Street; an elderly man in a cloth cap seen riding an old bicycle on Louth's bypass, who mysteriously disappeared; and

The Riseholme tumulus.

Does the Faceless Man still haunt the path via Boultham Park's lake?

the story of how a kindly local eccentric, Miss Francis, was seen dressed in her usual gabardine mackintosh and wheeling a pram along Seaholme Road, Mablethorpe, in the 1960s – two days after she had died. In 2005 the *Echo* reported on yet another haunted pub: the Jolly Brewer on Lincoln's Broadgate, where a mysterious 'voice from another world' harangued the staff by calling their names.

There are stories emerging that Boultham Park, Lincoln (the former Ellison family estate and site of Boultham Hall, pulled down in 1959), was at one time haunted by a phantom man wearing a long, light-coloured mac and hat, who had no face. He appeared in 1977 one evening beside the lake when two girls were walking through the park, moving in a 'floating' manner. Oddly, he was seen by one girl, but not the other. Upon enquiring later, the girl who had seen the faceless man found there had been other sightings and the ghost appeared to be fairly well known even by then.

Lincoln's other former stately estate is Hartsholme Park, and this author recalls a vague (and unlikely) urban legend doing the rounds at the nearby City School in the late 1980s. This was to the effect that a pupil there was supposed to have seen a man's head floating along a 'lonely track' within the park. The detail was sparse: the head was dark-coloured, seen at dusk and supposedly had its eyes open. I recall it was believed to be linked to a highwayman who plied his trade on nearby Skellingthorpe Road, but it would be interesting to know if any other former pupils of the era recall the strange allegation.

In Scunthorpe, the reports are even weirder. Scotter Road, south of the viaduct, is said to be haunted by a bizarre-looking thing that resembles someone in fancy dress, but which is so tall it looks as though they are walking on stilts. It reportedly vanishes inexplicably. The entity is said to have appeared at night on one occasion, and been clearly visible to multiple witnesses for several minutes by the light of streetlamps. Lately I have been informed that the 'fancy dress' was something resembling a monk's habit.

It is clear that in 2020 there is no indication 'ghosts' have become consigned to the superstition of a bygone era. It makes one wonder how it will all be viewed in 100 years of time. Perhaps the mystery will have been solved, or perhaps we will be no further forward with an explanation than we are today.

The viaduct in Scunthorpe where the elongated entity appeared.

Part II: Footsteps into the Unknown

Introduction

Lincoln's most famous legend is, of course, that of the Lincoln Imp. This grotesque little specimen, late thirteenth century in origin, with its broad grin, horns, hairy body and cloven hoofs, sits cross-legged high up on a pier in the Angel Choir.

Everyone has heard a version of why he sits there, although these traditions have a forerunner in a story about the Devil. Arnold Frost, in his ballad *The Wind, The Devil and Lincoln Minster* (1898), recorded that the coming of the Norman bishop Remigius to the diocese of Lincoln so angered the Devil that he attempted to kill him by the cathedral's south-west corner. The bishop, however, called for help from the Blessed Virgin Mary, who appeared and whipped up a tornado that drove the Devil inside the cathedral – from where he dare not come out. This primitive version

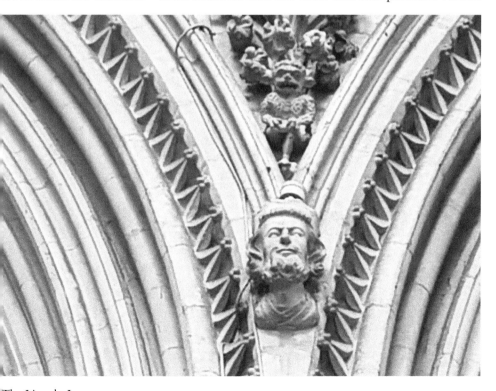

The Lincoln Imp.

of the imp legend was told to Frost *c.* 1892 by a North Lincolnshire man, who had heard it fifty-odd years earlier from his father.

Frost was also told a second story in the 1890s of two imps taken by their elemental friend the wind to the cathedral, one of which became petrified into stone by the holy magnificence of the interior. This is the imp that now looks down from the Angel Choir. The other imp alighted upon 'a certain witch' by the exterior Judgement Porch. It too was turned to stone, alongside the witch. The wind continued to billow outside the building, waiting for the two imps that never came back. (As one who daily walks through Minster Yard between Eastgate and Exchequer Gate, I can state unequivocally that the cathedral's west front can be weirdly blustery, even when Eastgate is relatively balmy!)

The second imp clings to a witch's back above the Judgement Porch. From Sympson's *Lincoln* (1906).

Lincoln Cathedral's strangely blustery west front.

These stories, broadly, formed the template for all the versions of the Lincoln Imp legend that came afterwards. The creature presents such a remarkable contrast to the beautiful carvings about it that it is no wonder such tales developed.

This writer has also learned via witnesses of what may be a developing tradition within Lincoln Cathedral. Two visitors have independently explained to me that while they were taking photos using their mobile phones, a small blurry grey 'thing' flitted in front of them which, when they tried to spot it with the naked eye, couldn't be located. Both witnesses have speculated, half-seriously, that this was the 'Lincoln Imp', the prism of their mobile phone camera somehow allowing them to see it moving about. In one instance the sighting was made while standing looking at Bishop Grosseteste's tomb in the south-east transept. One of the witnesses even told me he saw the roped-off barriers in the nave thrown over 'on their own' during choir practice early one evening, shortly after seeing the flying 'creature'. Presumably, bats or pigeons are responsible for the sightings of this 'imp', blurred observation via phone cameras, rather than the naked eye, allowing each witness to interpret their sighting as something 'inexplicable'.

Returning to the Devil, for centuries there has been a saying, 'He looks as the Devil did over Lincoln,' taken to be a reference to Satan's outrage at the building of the cathedral. In the 1950s, the present writer's grandfather would tell his children that the Devil ended up tricked and imprisoned in the conical chapter house St Anne

The cathedral's chapter house well.

This ornament adorns a house on Lincoln's Steep Hill and is allegedly an abode for the Devil.

Well building on the cathedral's eastern side. If one were to run round it seven times, and peer through one of the six holes, the Devil's red eyes would be seen glaring back at you.

More recently, in 2018 I was told by a North Hykeham resident that a tiny decorative ornament sitting on the roof ridge of a dwelling on the eastern side of Steep Hill, in the cathedral's shadow, was a 'Devil's house'. It was, apparently, put there to offer any passing imps or demons a resting place, and lessen the chance they might enter the house itself.

Lincoln wasn't visited only by the Devil and his imps in days gone by. Ancient legends sometimes paint Lincolnshire as an otherworldly, Tolkien-esque land, where mythical beasts were challenged by local champions. In many cases there are modern equivalents, often mind-boggling in their bizarreness. And the deeper one delves, the stranger things can become. The scale and scope of Lincolnshire's paranormal mysteries is truly amazing. Strange creatures, UFOs, weird phenomena and glimpses into the future … it seems that if it can be imagined, there is an example of it in our county.

The Grimsby Mermaid

In February 1809, a curious mermaid reportedly approached a ship lying off Grimsby. The sloop, out of Beverley, was at anchor in the Hawke Channel, between Grimsby and Spurn Head, when a cabin boy saw a woman in the water some distance away. Supposing she had by some accident fallen overboard from another vessel, the boy raised some fellow crewmen with the intention of taking a small boat out to rescue her.

As they scanned the water trying to spot her, and fearing she may have drowned, she suddenly reappeared near their vessel, and those on board were left in no doubt they were looking at 'a creature of the mermaid species'. According to the *Ipswich*

Journal: 'They perceived her shake herself, and put up her hands to shade back her hair, which was very long and quite black. Her appearance they describe as that of a blooming country girl.'

Pixie Lore

A modern piece of fairy, or pixie, lore was passed to this author in 2007 by an employee of Siemens in Lincoln. She recalled being told around twenty-five years earlier, when a little girl, that in Norman times the proposal to establish a cathedral in the old Roman city of Lincoln prompted a rebellion among a native 'pixy race'. They subsequently fought a terrible battle with neighbouring fairies (who approved of the cathedral) in the area where the Lion & Snake public house now stands. The fairies won, the pixies were vanquished and Lincoln Cathedral was built. As evidence of this, as a child she had often had pointed out to her a little cross that was carved on a stone in the ancient wall running along East Bight near Newport Arch. The symbol was variously described to her as either a small cross, or a tiny sword. My informant was told this by a family member. Additionally, she was told this stone was 'a Norman one' created as a souvenir of the event at the time and subsequently incorporated into the East Bight wall, which was built some centuries later. (At the very least whoever

Bears have been queuing at South Willingham's bus stop since *c.* 2005. From time to time they are replaced, but village legend says the original ones were spirited there by fairies.

told her this tradition seems to have known Lincoln's history.) A handful of people I have talked to about this since say they 'remember being told something like that' in their youth. This author was shown the carving at the time, and recalls it being in the section of wall approximately opposite the portion of Roman remains. Today, however, it seems lost.

Lincolnshire has a number of odd fairy legends. S. O. Addy's *Household Tales …* (1895) for example tells of a primitive road leading out of Crowle that will now never be finished or modernised, following a meeting between a local farmer and a mysterious stranger there. Discussing the road, the stranger explained it was within his power to complete it there and then, if the farmer would only turn his back and not observe proceedings. Although he did as asked, after some time the farmer became intrigued by the tinkering and hammering behind him. Whirling round, he saw 'a number of little men working at the road.' They vanished in an instant, and the road returned to its former condition, never to be mended. One wonders if perhaps the bridleway across the Crowle Waste at the end of Dole Road is the road in question.

South-west of Horsington, a mound in the middle of a patch of woodland marks the site where the old church stood. According to Reverend Penny's *Folklore Round Horncastle* (ed. 1935), the reason why the replacement church was not built at this same spot was because 'fairies removed the stones by night as fast as they were built by day, till the plan had to be given up, and a new church built in the middle of the village (in 1860)'.

Another strange legend comes from North East Lincolnshire. According to the *Cornhill Magazine* in 1882: 'In an adjoining field to Beelsby a treasure is supposed to be hidden, and at times two little men wearing red caps, something like the Irish leprechauns, may be seen intently digging for it. Do not disturb them or on nearer approach you may find but two red-headed goldfinches swinging on a thistle.'

Many Lincolnshire fairy legends were collected from fen dwellers by Marie Balfour, who published them in 1891 in the journal *Folk-lore* under the title 'Legends of the Lincolnshire Cars'. Her stories paint an eerie, atmospheric picture of the Ancholme Valley region before drainage, depicting it as a wasteland morass haunted by spirits that had never been human – wraiths, witches and various fairy-like entities. One tale, 'The Stranger's Share', tells us the latter were called, almost interchangeably, Greencoaties (from their grass-green jackets), Strangers, Yarthkins (i.e. Earth-kin) and Tiddy People. In description they were 'no more than a span high, wi' arms an' legs as thin as thread, but great big feet an' hands, an' heads rollin' aboot on ther shouthers'. They wore grass-green jackets, breeches, yellow bonnets and had long noses, wide mouths and flapping tongues.

The most famous story Balfour collected was that of a toddler-sized water-dwelling elemental, clad in grey, with tangled white hair and beard, who limped as though lame and had a voice 'screechin' like tha pyewipe'. Local people called 'him' Tiddy Mun, although in reality the entity had no name.

The legend Balfour collected seems to take place in the 1630s ('afore the dykes were made and the river-bed changed') when Dutch engineers were imported to drain the northern Ancholme Valley wetlands, but this is open to interpretation. At any rate, as a result of the violation of his homeland, Tiddy Mun became angry, and a number of Dutch workers were either spirited away or found mysteriously suffocated in the mud holes. Local people blamed Tiddy Mun for this, but as the drainage project continued,

A depiction of Tiddy Mun (and a pyewipe).

the spirit's wrath became boundless and it next began to affect the community, for there followed bad harvests, pestilences and infant deaths. So the parishes, meeting fearfully at a cross dyke near the New River one night, presented Tiddy Mun with tributes of water, eventually regaining his favour, and once more hearing his 'soft and tender' pyewipe screech.

Each new moon, this pacification ritual persevered over the decades. Balfour was told of it in the late 1800s by an aged local woman, who had seen it performed when a youngster. Balfour's informant even thought she might have seen Tiddy Mun herself, in the fog, a long time ago. What became of Tiddy Mun, no one knows, but Balfour's source believed he had been 'frighted away' a long time since. Balfour wrote of her informant: 'To her, "Tiddy Mun" was a perfect reality, and one to be loved as well as feared. She is now dead, and I doubt whether anyone else knows the legend, which she said had been forgotten for many, many years, by all but herself and one or two old friends, all gone before her.'

Balfour possibly collected the story of Tiddy Mun from a native of Redbourne, where she lived briefly. East of this village, the New River cuts through the Carrs and crosses the Old River, and this may be the 'cross dyke' mentioned in her narrative. There was then (and still is) a tiny hamlet named Pyewipe south of Redbourne, which seems rather coincidental; believers in the legend may speculate whether it earned its name from memories of Tiddy Mun's pewit cry.

Possible site of the Tiddy Mun appeasement ritual, where the New Ancholme (left) crosses the Old Ancholme (right).

When the Devil Walked in Lincolnshire

Around the year 716 the king of Mercia founded a monastery at Crowland, in veneration of the pious hermit Guthlac. A generation earlier, Guthlac had come by boat to Crowland, then a remote Fenland island, and built himself a small rude dwelling in a large mound that had been formerly opened by treasure seekers. His hermitage was situated at 'Anchor Church Hill' (north-east of the subsequent abbey, on the southern edge of Postland Road). Guthlac's choice of abode was not a fortunate one, for the flooded landscape was haunted by sprites and demons. Felix, Guthlac's biographer, described these creatures as being of monstrous size, with blubber lips, fiery mouths, scaly faces, beetle heads, sharp teeth, long chins, hoarse throats, humped shoulders, big bellies, bandy legs and tailed buttocks. Repeatedly tormented by the forces of evil, Guthlac maintained his position, dying there around 714.

In 869, a diabolical apparition of Satan himself is said to have been conjured up at Crowland Abbey, cursing its blasphemous monks. The following year the abbey was plundered by Danish marauders, and its community massacred except for a ten-year-old monk called Turgar.

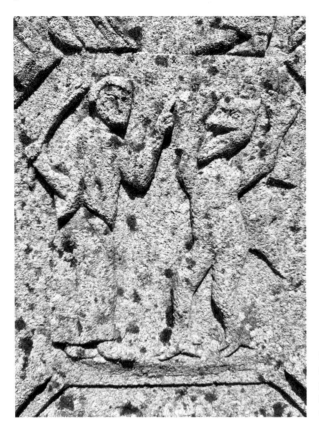

Guthlac beats back a demon, a depiction on a modern stone memorial at Crowland Abbey, reflecting an older, damaged version.

These demonic Fenland inhabitants retreated into the shadows long ago, although the Devil himself seems to have periodically emerged to pay a visit to Lincolnshire.

According to tradition, in the seventh century a primitive chapel once occupied the site where now sits Boston's famous church tower, known as the Boston Stump. The chapel was erected by Botolph, an Anglo-Saxon abbot and later patron saint of travellers. When he was strolling nearby one evening he encountered the Devil and expelled him by making the sign of the cross and preaching incessantly. During the struggle the Devil panted and gasped in such distress that he raised a whirlwind. This wind has never quite died away, hence the current of air still felt at that particular spot, billowing round the tower. In 1908, the tower was hit by lightning, causing one of the pinnacles to crash through the belfry roof; perhaps echoes of the Devil's exasperation were held to be particularly forceful that day. Perhaps he was even responsible for the 'Doom Birds' that perched high on the Stump in 1860 and 1928, in each case presaging the deaths of prominent Boston citizens.

In 1658 the Grantham-born philosopher Henry More wrote to Lady Conway, 'I have heard strange news since my last (correspondence) of one carried away and torn to pieces by the Devil in Lincolnshire, which is seriously reported here, and is believed by some, but I do not believe one syllable of it ...' Until at least the seventeenth century, the ancient tumuli at Revesby were said to be the scene of grand meetings between witches and the Devil, who appeared as a lion, bear or hydra-headed monster to terrify his assembled worshippers into compliance.

The Revesby tumuli.

In Tealby, at a curiously shaped rock overlooking the valley of the Rase, Satan was said to emerge upon hearing the midnight chimes emanating from Bayons Manor, and stride down to the river for his nightly dip. Witches reportedly conglomerated at the stone, known as the Devil's Pulpit. One wonders if associations with the Devil somehow 'cursed' Bayons Manor. By 1949 it was a dilapidated ruin, and in 1964 it was levelled with explosives.

If one really wanted to see the Devil that badly, Digby might be the place to go. St Thomas a' Becket's churchyard is haunted one night a year by a man on a white pony. Another legend has it that if you run twelve times backwards round

The Cooke tombs at Digby.

Robert Cooke's tomb, the rattle of crockery can be heard. However, might this not be chains? For an article in the *Poacher* (Autumn 2014) suggests if you walk four times backwards round a 'rectangular tomb' outside the church door (presumably Cooke's) the Devil will appear.

At Burgh le Marsh, running 'withershins' (contrary to the sun's course) around the church three times after dark prompts the Devil to appear in the porch.

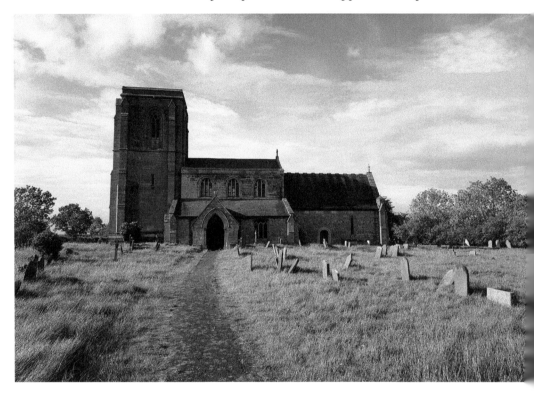

Above: What was – or is – the Devil's fascination with the church at Dorrington?

Left: At Melton Ross, the Devil appeared *c.* 1790 as a three-legged hare, distracting children, who returned to find one of their friends had accidentally hanged himself on a nearby tree. This gallows structure was put up in remembrance.

Rudkin's *Lincolnshire Folklore* (1936) has a fascinating snippet: 'G.H., still living in 1934, saw a white rabbit on Church Hill, Dorrington, which turned into the Devil (so he says).' Dorrington church seems to have had a unique allure to witches and the Devil. On certain bright moonlit nights, it used to be said you could look through the keyhole and see the Devil amusing himself playing at glass marbles.

Today, this belief in Satan as a genuine, malevolent presence is reflected in the goings-on at St Botolph's Church, a medieval ruin sitting alone at Skidbrooke in the empty, flat wastelands west of Saltfleet. Unused since 1973, the church has long been rumoured to be cursed and badly haunted: the *Louth Leader* reported in 2004 that the ghosts of 'small babies among the gravestones and grass' had been seen by paranormal investigators. Since the 1970s, the church has earned the nickname 'the Devil's Church', and there are appalling stories of vandalism, animal sacrifice, witchcraft and grave desecration. I have heard it said that skeletons were once taken from coffins and propped up against the church wall in a line, which I sincerely hope to be an urban legend.

During a visit to the ruin on 31 July 2017, this author with his family found disturbing signs of fires and vandalism, and satanic symbols were scrawled on the walls. One terrifying piece of graffiti announced, underneath the memorial to a former vicar's wife, 'LEAVE. THE DEVIL IS HERE.'

Satanic vandalism at Skidbrooke church.

The gargoyle in question.

A Gargoyle Mystery

On a similar theme to that of the imp carving, a small mystery currently surrounds a twenty-first century gargoyle on Lincoln Cathedral's south side, that of a snake with a human skull and hands. The carving was a replacement for a worn medieval grotesque, with a worm-like body. The new version has a skull with pound signs carved in its eyes, apparently a symbol for greed, and for some reason a tradition seems to be developing whereby people place offerings of coins on this creature's clenched fist. I discovered in February 2019 that visitors had begun doing this, but at the moment the reason why this carving is venerated in such a way is unknown.

There are a number of theories, one being that avaricious people are paying 'it' in the hope of becoming wealthy. Another suggestion in particular caught my attention: that the sculpture (in both its medieval and modern incarnations) represented what greedy people turn into when they go to Hell. Therefore some are literally paying the gargoyle out of caution or fear; in other words, to ward off the influence of greed from their household.

Witchcraft

A purge on witchcraft was enacted in the East Midlands around Christmas 1618 when Joan Flower, her two daughters and three others were accused of using curses and enchantments to remotely murder the two young sons of the Earl and Countess of Rutland. The two daughters, Margaret and Philippa, had formerly been employed by the earl at Belvoir Castle, but been dismissed. Both were executed at Lincoln on 11 March 1619. One interesting aspect of the case is Margaret Flower's confession that on 30 January four devils appeared before her in 'Lincolne Jayle' near midnight. One stood at the foot of her bed and had 'a blacke head like an ape' but she could not understand what it was trying to tell her. The other three were supernatural 'familiars' called Rutterkin, Little Robin and Spirit.

These horseshoes mark the point where Byard took off.

Mother Flower never saw trial. While being transferred from Rutland to Lincoln, she called for bread and butter, stating that it would never go through her if she were guilty. Upon partaking, she promptly collapsed and died, and was buried at Ancaster.

Witches might also be men. Later that century a cobbler named Follet, with aspirations to be a 'wise man' and astrologer, bewitched the daughter of a Leasingham farmer, William Medcalf, tormenting her with a demon in the form of a fair-haired man. This entity was visible to her alone, and plagued her by rattling her milk dishes, spoiling her cooking, matting her hair and so on. Follet was also suspected of causing a notorious poltergeist manifestation in 1679 at Sir William York's house in the parish.

Lincolnshire has a long tradition of witchcraft. Not far from where Mother Flower died, where the road to Newark crosses the Roman Ermine Street, is the hamlet of Byard's Leap. Here, a famous bay horse, carrying its heroic rider, is said to have made prodigious leaps in escaping from a witch that terrorised the locality. Sets of horseshoes mark the points where Byard took off and landed.

One of the most fascinating aspects of Lincolnshire witches are the allegations – repeated for centuries – that they were able to shape-shift. According to Gervase Holles, in notes on Lincolnshire churches made 1634–1642, auditors inspecting Bolingbroke Castle were plagued by a 'certaine spirit, in ye likeness of a hare'. It continually seemed to vanish into thin air whenever it was chased and cornered in the castle's nooks and crannies, and hounds brought in to hunt it down ended up retreating, whining dismally. Although Holles does not explicitly say so, the assumption is that, rather than a phantom animal, this hare was either a witch's familiar or else an actual witch, manifested as a hare. Curiosity about this apparition lingered long, for a correspondent to the *Boston Guardian* noted in 1938: 'The witch that turned herself into a hare, and ran riot in the old castle, still persists to dodge about the castle field. I saw two there a short time ago, so imagined that the witch had taken to herself a husband.'

Some incidents submitted to *Lincolnshire Notes & Queries* (October 1889) by Revd W. Henry Jones, of Mumby Vicarage, suggest this belief continued well into what might be considered a more enlightened era. His servant, from Kirton-in-Lindsey, told

Bolingbroke Castle, where the hare ran between the auditors' legs 'and sometymes overthrows them'.

him, 'One night my father and brother saw a cat in front of them. Father knew it was a witch and hammered it. Next day the witch had her face all tied up (bandaged), and shortly afterwards died.' Then there was the case of a cat that entered a house at Grasby and was attacked and beaten. A little later, a local woman died, and when she was laid out her body was observed to be marked in exactly the same place the inquisitive cat had been struck.

Around the mid-1800s a farmer who worked the land extensively at Bunker's Hill, Lincoln, was told by an employee of a large old hare being seen by moonlight in a field. When the farmer fired at the animal with his gun there was a woman's scream, and the party discovered that, although the hare had gone, there was a trail of blood leading across the field. The farmer assumed he had hit the local 'witch', in the form of a hare, and she 'was supposed to have been killed'. This woman the farmer blamed for plaguing him with spells. For instance, on one occasion when loads were being brought in on Wragby Road, she used magic to overturn a cart three times, eventually forcing them to take it to its destination via Hawthorn Road. This family tradition was told by the farmer's great-grandson, Mr R. Fowell, and appeared in the *Echo* in 1937.

As late as 1922, a widow called Mrs Mitchell was tried at Spalding Petty Sessions for stabbing her neighbor in the wrist over a dispute in Whaplode. During her attack Mitchell had used the phrase 'You won't witch me anymore', and the bench heard that it used to be thought a witch's powers could be dispelled if her blood were made to flow. The case was dismissed, but it does illustrate how superstitions around witchcraft lasted a lot longer than one might think.

Perhaps belief in the shape-shifting ability of witches lingers still in Lincolnshire. This author, while working for a printer-deliverers company in east Lincoln in the mid-1990s, recalls a fellow driver explaining how his father had once caught an ownerless cat, put it in a sack, killed it with a hammer and thrown it into a local river, possibly the Witham. This terrible act of cruelty stemmed from a belief that

the animal was 'evil' and responsible for a series of unspecified misfortunes that had plagued the family since it began approaching their house. Though not stated directly, the implication is that the episode was somehow 'witchcraft' related.

The Weirdest Ghost

Anciently in the parish of Knaith there sat by the roadside a cottage, inhabited by an old widow called Mrs Dog. She was murdered by 'a bagman' for her supposed wealth, and shortly afterwards the cottage was pulled down.

In the nineteenth century the site of the house was believed to be haunted by a spectral black dog – that had a woman's face. The creature materialized from between two small hills situated behind where the cottage had once stood on the Trent side of the road.

The anecdote was told to folklorist Ethel Rudkin by an occupant of Old Brumby Hall, and featured in a 1937 article for *Folklore* entitled The Black Dog. The informant stated that, in his youth, he recalled people being genuinely frightened to pass that way at night.

Wolf-like Entities

In 1898 a contributor to *Notes & Queries* recounted a piece of were-creature lore from Lincolnshire. In a village in West Lindsey there had lived a lame old man, widely regarded as a wizard. He possessed the ability to transform himself into a black canine-like animal, in which guise he would attack livestock. On one occasion a famer saw the creature biting his cattle, and, rushing to help, he witnessed the canine turn into the wizard before his eyes.

This were-creature seems to have been connected in some way to witchcraft and the spectral black dogs that haunted the region, although Lincolnshire also has a small crop of traditions concerning werewolf-like entities. According to Marlowe's *Legends of the Fenland People* (1926), in the mid-1700s a witch named Mother Nightshade transformed into a 'ferocious and abnormally large grey wolf' at her cottage in Gedney Dyke and tore apart a youth called John Culpepper, who had come to her for advice. Locals subsequently burned the cottage down, but the witch apparently escaped, and for years after the howl of a wolf was heard drifting across the marshland plains.

The famous Dogdyke werewolf was not, however, a flesh-and-blood creature, more a terrifying entity conjured up from another dimension. Again according to Marlowe in 1926, an archaeologist living at 'Langrick Fen', near Dogdyke, unearthed a human skeleton with a wolf's head at a local prehistoric site. Carrying the mysterious remains home, his house was besieged in the night by a monstrous upright creature with a wolf's head that smashed a window and gained admittance, padding round the dwelling while the archaeologist cowered behind a locked kitchen door. Thinking the creature was looking for the uncanny relics, the archaeologist reburied them the following morning. Perhaps they still lie there, waiting to be unearthed again! When these events are supposed to have occurred is unclear, but it is possible it was during Marlowe's lifetime: the fact that he does not specify otherwise suggests he collected the story from a contemporary.

Could a werewolf-like entity really have roamed the flat landscape at Langrick?

That Lincolnshire werewolves were phantasms is further suggested by an article in the *Grantham Journal* in 1898. This explained that Lincolnshire's roads were haunted by the 'weir wolf', a 'tall, gaunt, fearful-looking animal'. It was generally harmless, although extremely frightening to see. One person who did see it, ahead of him on a lonely road in north Lincolnshire at dusk, threw a stick at the creature, which had the effect of making it seemingly fragment, then reform before evaporating into thin air. The person who collected this anecdote, John Gee, claimed the story had come from a man of the past generation who was of impeccable character. Gee dated the 'weir wolf's' last appearance on the county's roads to around the early 1800s.

A Freedom of Information request in 2011 revealed that two 'werewolf' sightings had been reported to Lincolnshire police over the past five years.

Rumours of the Lincolnshire Sasquatch

Strange though it may seem, there is a small but growing number of people who believe that the UK countryside hides specimens of a giant, hairy humanoid creature that is becoming known as the 'British Bigfoot'.

This creature has something of a pedigree in the 'Wild Man of Stainfield', a somewhat confused legend collected in the early twentieth century by Revd James Alpass Penny. Although there are numerous versions, the most familiar tells how a member of the local Drake-Tyrwhitt family was offered Stainfield and Lissington if he would kill a 'Wild Man' terrorising the area. The ogre's location was betrayed by the fuss a group of pewits were making, and Drake-Tyrwhitt ran the Wild Man through as he slept on the ground. The man-creature leapt up and, streaming blood, chased him for a mile. Eventually the Wild Man stumbled and Drake-Tyrwhitt turned his horse about, riding up to finish his adversary off.

People will tell you that this encounter occurred anywhere from King John's time to the early Victorian years. If there is even a glimmer of truth in the legend then logic might suggest the setting was around the reign of Henry VIII – given this was when Sir Robert Tyrwhitt acquired Stainfield. Also, the family crest of a wild or savage man can be traced back to 1541. (The line did not become 'Drake-Tyrwhitt' until some 200 years later, which seems too late for the legend.)

The story of the Wild Man has been familiar to generations of families, and there is some interesting additional detail, including that he was killed running from Fiskerton to Stainfield, his blood 'staining the fields' and thereby earning the latter place its name. Also, the ogre was said to have been fatally wounded in Fiskerton Wood, his blood permanently staining a nearby stone black, and his cadaver is allegedly buried under a stone just outside Stainfield's church. The general perception of the Wild Man seems to be that he was some kind of club-carrying ogre or caveman who lived by killing livestock and, in some versions, people. Sometimes he is described as yeti-like, unclothed with hair all over; other times (as per one quote), 'he looked dirty and untidy with dark curly hair'.

Tattered banners that formerly hung in the church were mistakenly believed to be the Wild Man's clothes, and are now in the Archives Office, Lincoln. Funerary armour – consisting of gloves and helmet surmounted with the wild-man motif – was stolen from the church in 1995. A misericord dagger – the supposed instrument of his death – is also missing. Today, this mysterious Wild Man's image adorns the church: there is a small figurine of him, and a very impressive banner depicting him. There is even a striking, life-size dummy of him, club and all.

A number of online forums reference a vague incident that occurred late in 1970, when a man is said to have seen a very tall entity that appeared half-man, half animal near Dorrington's railway bridge. Apparently his experience terrified him so much he contacted the police. (Is it merely coincidence that Rudkin's *Lincolnshire Folklore* (1936) makes a passing reference to the Shag Foal lurking beneath the same bridge?)

However, if such a thing as Bigfoot exists in Lincolnshire, then it must surely be other-dimensional rather than a flesh-and-blood animal.

In 2014 there was national media interest in a photo taken by Adam Bird, co-founder of the British Bigfoot Research group. Following rumours of a Bigfoot-type entity in the Friskney nature reserve, Adam heard strange noises during a visit and found

A mannequin of the Wild Man in Stainfield's church.

Dorrington's railway bridge is haunted by a humanoid.

'suspiciously large footprints'. Furthermore, he later discovered that one photograph he had taken appeared to show something resembling a large dark figure watching his group through the trees from afar. The story was picked up by the local and national media that December. The fact remains that the woodland around Friskney is scattered and sparse, used until 1878 for decoying ducks, and in no way is substantial enough to hide a bigfoot, even in the unlikely event that such creatures actually inhabit Lincolnshire's remoter parts.

Bradley Wood, from Bradley Road. A small parcel of woodland, but one of a growing number said to be inhabited by strange humanoids.

Ditto Bradley Woods, near Grimsby, where a striding figure was photographed, later nicknamed the 'Bradley Bigfoot' after the image appeared in the *Grimsby Evening Telegraph* in 2019. The figure is clearly humanoid and admittedly somewhat mysterious, but unless the Lincolnshire Bigfoot wears trousers, then it would appear to be a misidentification. Of what, or more likely who, is at the time of writing unknown. Bradley Woods probably has enough to contend with already, it being the haunt of Grimsby's most famous apparition: the tormented 'Black Lady'. However, reports of this type are becoming ever more frequent; at the time of writing the *Star* (23 February 2020), among others, has picked up on an allegation that a 10-foot-tall humanoid figure 'darker than the night' was seen crossing the A18 at Kirmington. It apparently left two deer limbs scattered on the roadside in its wake.

Dragons, Giant Snakes and Sea Monsters

According to an ancient Court Roll: 'Ther reigned at a toune called Wormesgay (Walmsgate) a dragon in a lane in the field that venomed men and bestes with his aire.' Hugh le Barde, of Castle Carlton, did battle against this dragon 'upon a weddings day' and slew it. The head of the loathsome creature was separated from its trunk and taken by Hugh to London. It was presented to King Henry I, who bestowed important privileges upon Hugh in recognition of his actions.

Today, the moats and mounds of Hugh's castle, a motte-and-bailey structure, can still be seen at Castle Carlton. Later folklore described the beast as having a long scaly body, short iron-shod legs, lashing tail and one blazing eye set in its head, the size of a basin. Its one vulnerable spot was a wart on its right thigh, protected by three layers of brass. According to tradition, its lair was at Ormsby, while Walmsgate is where it was slain. An ancient long barrow there is where the dragon's trunk was interred.

Walmsgate's long barrow, glimpsed through the trees. Are a dragon's remains really deposited beside the A16?

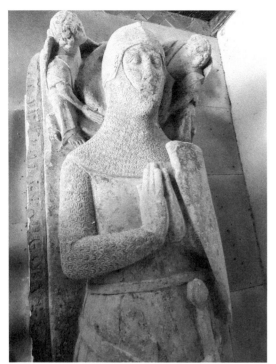

Above left: Tradition avers this stone effigy in Buslingthorpe's church is that of Sir John, slayer of the Scampton area dragon.

Above right: The crest of this local school also references Sir John de Buslingthorpe's dragon slaying.

The hamlet of Dragonby owes its name to this rock formation – said to be a petrified dragon. One visitor's comment recently passed to the author posited, 'The green mould on it means it's coming back to life.'

The Drake Stone, of which there are many legends, seemingly broke into two when it was moved near the churchyard gate around 1913.

Traditions of dragons and dragon slayers also come from Ludford, Scampton, Dragonby and Anwick. At the latter place, the Drake Stone marked the site of gold that, in some versions, was guarded by a demon in the form of a dragon. Centuries ago, a man named Robarts is said to have used oxen to try and shift the boulder, but instead released a drake or dragon that flew into the air and disappeared in smoke and flames. (This was told to Revd G. Oliver in 1832, by an old man who stated the legend went back at least five generations in his family.) According to an article on the legends in the *Lincolnshire Chronicle* in 1901, there was excitement around 1737, when 'a great four-legged dragon', with flames of fire flashing all around it, was reported at the stone. It turned out to be an ass tethered by two night-time treasure hunters. The stone was at the time situated in a field on high ground a mile north-west of Anwick's church, but around 1913 was moved to the churchyard.

Compare these legends with the claim of Mr S. Weatherell, a yardman at a farm in Holbeach-St-Matthew. In July 1953, Weatherell discovered three dead pigs, each with two small punctures in their left ear. Soon after, he caught sight of a monstrous 6-foot-long snake with a cobra-like head. He spotted this creature on numerous occasions on the farm's premises, including in the pig's field and curled up near the water tank, leading to extensive searches by Spalding police and a shotgun-wielding gamekeeper. The snake was never captured and the search was abandoned in August. Mr Weatherell's sighting was not validated and the matter never really explained.

Even more impressively, there were reports throughout the twentieth century of sea monsters exploring Lincolnshire's coast. The *Hull Daily Mail* (5 February 1934) reported that the lines of inshore fishermen off Cleethorpes were being destroyed by some gigantic marine animal, although it was never ascertained what it was. Fishermen in a boat off Grimsby docks who spotted a titanic sea creature in the mouth of the Humber swimming out to sea rationalised it as a shoal of porpoises, while others believed they had spotted a monstrous, 8-foot-long seal in the vicinity of the fishermen's lines. After a 6-foot seal was killed, the matter seemed settled, although one Cleethorpes fisherman of fifty-one-years standing, William Croft, was skeptical. He and his sons had seen an 8-foot long creature, with a longer neck than a seal's and a head like a Great Dane with ears and a mane. He was definite in his opinion it wasn't a seal, having seen the creature from 50 yards distant.

Two years later, another large, mysterious 'serpent' was being spotted in the mouth of the Humber Estuary, including by Mrs Tuck of Grimsby. That August she saw something tearing through the water at terrific speed while she walked along the

north wall of the new fish dock. The creature was black and moved in an undulating serpentine manner in the direction of Immingham, around half a mile from her. Its above-water contour was oval. When a stranded, dying whale, with mottled black and grey skin, was discovered by a party of campers on the Humberston coast, the sightings were laid at its door. Again, not everyone was convinced. Another witness, from the same north wall vantage point, interpreted his sighting as a beast with 'four or five humps about 200 yards offshore'. These humps moved slowly, disappearing and then appearing again. In 2016, then in his eighties, the witness reminisced in the *Grimsby Telegraph*: 'I can still see it very clearly in my mind ... I was never comfortable swimming in the sea at Cleethorpes after that day!'

Thirty years after these sightings the *Skegness Standard* (6 November 1966) reported the claim of a Boston man to have seen a huge snake-like creature off Trusthorpe in 1937 or 1938. No head was visible, but four or five half-links of a partly submerged serpentine body protruded above water, no more than 400 yards from the water's edge. He was adamant this creature, which submerged after five minutes, was not a school of porpoises, etc.

This reminiscence coincided with a new wave of sightings, 1966 becoming another 'monster fever' year for Lincolnshire. Among the reports was that of George Ashton, of Sheffield, who told the *Standard* that on 16 October that year he and his wife had seen a serpent-headed beast with several pointed humps travelling 100 yards offshore between Chapel Point and Ingoldmells. Mrs Ashton agreed the animal was 'a living creature of the sort which neither my husband nor I have ever before seen'.

Winston Kime's *Skeggy!* (1969) indicates the creature's enduring celebrity: 'A party from Wainfleet, visiting Gibraltar Point, saw this strange object, nine or ten feet long, moving swiftly through the water in the direction of Skegness ... The "monster" has been reported off Skegness several times since.'

Did a sea serpent really visit the waters off Skegness in the 1960s?

Hosts

Revd Penny, in *Folklore Round Horncastle* (ed. 1935), collected a number of revolting stories of human beings who had somehow become hosts to living creatures that had managed to get inside their bodies and set up home there. These included a workman around 1865 at Bracken Wood, Woodhall Spa, who had been ill for some time and suddenly vomited up a live newt, and a sick man in Horncastle who brought up a big living toad.

Worst of all is the story of a woman who lived in Wildmore Fen, between Coningsby and Boston, who had somehow gotten a live snake inside her. This creature would sometimes poke its head out of her mouth, but always retreated back into her gullet whenever anyone tried to grab it. The woman suffered this torture for years before dying of it. As to when it occurred, we are only told by Penny (writing in the early twentieth century) that it was a long time ago, before Wildmore Fen was formed into new parishes.

The mystery, assuming any truth in these stories, is how these creatures got inside their hosts. Had the victims somehow unwittingly swallowed them as eggs or larvae? The suggestion of them having been bewitched is also inescapable. Most of all, one wonders how the hosts even survived with these things feeding on – and growing inside – them.

Phantom Big Cats

Long ago, they told of a spectral canine apparition, named 'Hairy Jack'. An entry in *Lincolnshire Notes & Queries* (1896) observed: '"Hairy Jack" was to be met with in the parish of Grayingham some years ago, and phantoms of the same breed are said to prowl about lonely plantations, by-ways and waste places, to attack anyone passing, although it must be confessed that proof of injury actually inflicted by them is hard to obtain.' Folklorist Mabel Peacock added to this in 1908: 'Grayingham may be a mistake. Properly speaking, I am told, it should haunt an old barn on Willoughton Cliff, some distance further south.'

Today you are more likely to witness a large, sinister, out-of-place panther-like animal than a spectral hound. These have been glimpsed for decades, since at least the 1970s, and although they have left occasional tantalising evidences of their corporeal existence, genuine proof that they prowl the Lincolnshire countryside remains somewhat elusive.

In February 2015 I learned from a friend who worked for the Animal & Plant Health Agency that a local veterinary practice retained a plaster cast of a large feline paw print, found some eighteen months earlier. The prints had been discovered in a muddy field 'somewhere near Market Rasen', and were 'definitely not those of a domestic cat'. I was gravely warned that 'some people say there are those living in the countryside who keep tigers, and one of them got loose'.

The most compelling evidence for alien big cats comes in the form of eyewitness accounts, of which there are far too many to outline here. Suffice to say, the enigma is ongoing and widely reported. The *Mail* (24 August 2017) was just one newspaper that covered the experience of a delivery driver who'd spotted a large, black panther-like creature in a field near Obthorpe. Stopping his vehicle in a country lane, he'd even

managed to get a grainy, but half-decent, daylight photo of the animal, although his view with the naked eye had been much superior. The witness was convinced he had seen a giant feline.

Large cats roaming the area about Stamford, as in most parts of Lincolnshire, have sometimes been reported. Around 2014 the proprietor of the Rutland Falconry & Owl Centre, where eight leopards were kept, was contacted by a concerned woman who asked him whether one of his leopards had escaped; after checking, and ascertaining, all was OK, he asked her why she thought such a thing. The woman explained that it was because 'three lads' in the bar at Barnsdale Lodge had been overheard saying they had spotted 'a large, brown cat' crossing the road somewhere in the vicinity, it's form caught in their car's headlights. When the Falconry Centre's owner hastened to the lodge, he found the men still in the bar and was told the same. In explanation, he suggested a black panther's coat might appear brown when captured in the unnatural light of a headlamp, and furthermore that he believed it entirely possible such an animal could sustain itself in the wild.

The proprietor told this story to a friend of mine visiting the centre, who in turn passed it on to me in August 2014.

Monkey Puzzles

In the 1990s, this author's father (when clerk for Ruskington Parish Council) was told by a local lady that the monkey carvings at the Black Bull, Rectory Road, 'magically came to life at midnight and ran round the village'. This tradition, passed through the lady's family, was no more specific than that, but there are reports of actual mystery monkeys elsewhere.

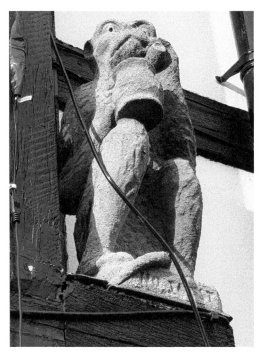

One of the Black Bull's monkeys, complete with beer and pipe.

In August 1976 local and national newspapers reported a 2-foot-tall monkey was being spotted in the Blyton/Northorpe area, with witnesses describing it as dark brown and having bright eyes, pointed ears and a square face. In September 1979 the media reported that a group of monkeys (supposed to have escaped from an unidentified 'travelling circus') were spotted swinging through trees at Stamford, after previously having alarmed the residents of Exton, Rutland.

In August 2010 even the BBC reported the experience of a policeman who, while driving his patrol car on Mill Hill Way, South Cockerington, near midday saw a small monkey run in front of his vehicle. It paused on its hind legs, looked at the surprised officer, then scampered over a hedge. Another PC subsequently claimed to have seen the same animal on 15 August (two days after the first sighting) in the same location. The primate was described as tiny – little bigger than a squirrel – and dark brown with a long tail pointing straight upwards.

East Lindsey District Council reported they had issued only one license for such an animal and that monkey was accounted for. So in each case where did these animals come from? As with the black panthers, it's almost as if they simply 'appeared' through some weird portal, and then scampered off into the Lincolnshire wilds, never to be seen or heard from again.

On 26 June 2020, during a rainstorm, a large turtle-like animal was seen and photographed in a body of water on Lincoln's West Common. It was perched on a tree branch poking above the water; and although surrounded by beer bottles and other sad debris cast into the pool, the mystery animal appeared to be craning its neck and nonetheless enjoying the downpour. It all goes to show you never know what's out there.

'Take Me to Your Leader'

In 1971 Grimsby Police's private mobile radio frequency was intercepted, and police patrol radios began to pick up unnerving noises: a cacophony of screeches and warbling that climaxed with a high-pitched, squeaky voice demanding, 'Take me to your leader!'

Contact with Grimsby Police HQ was severely disrupted. According to the *Mirror* (31 October 1971), 'It came as police were being swamped with calls from people who said they had seen an orange, cigar-shaped object in the sky.' The *People* also reported the incident, adding, 'A police spokesman said, "We are beginning to think there is a joker at work."'

If indeed joker there was, however, they do not appear to have been caught.

Unidentified Aerial Phenomena

With the above in mind, it is a rare person who has not, at some point, seen something weird in the sky. Accounts of what were originally 'flying saucers', then 'UFOs' and now 'unidentified aerial phenomena', go back decades in Lincolnshire. At 7.25 pm on 2 September 1954, for instance, a sizeable round white disc soared through the sky towards Bourne from the direction of Boston. It was described by witnesses as soundless, luminous, almost opaque, and at a height of 40,000 feet. It left no vapour trail and seemed to be made not of metal, but some form of plastic material. A former

RAF instructor, atop a tree picking apples in Gosberton, described its speed as 'truly phenomenal'. It was clearly distinguishable from a Meteor jet that had passed west to east at 10,000 feet immediately before.

Two years later on the afternoon of 22 September 1956 there occurred a famous sighting – made by hundreds on the promenade at Cleethorpes – of an object resembling a glass sphere at 54,000 feet. It seemed to have something white inside it. Approximately 80 feet in diameter, it hovered silently for an hour against a 40-mph wind, but simply disappeared when approached by two fighters. According to Reader's Digest *Folklore, Myths & Legends of Britain* (1973), 'The event has never been satisfactorily explained.'

Over the decades there have been many allegations of UFO sightings in Lincolnshire, including the widely reported 'Wash Incident' of 5 October 1996. This concerned a stationary object, which had flashing red, blue and white lights, and appeared to be rotating, that was seen above the bay of the Wash from multiple locations over seven hours. The object was visible on military radar throughout, although these signals were later blamed on the Boston Stump distorting communication systems. Misleading radar echoes wouldn't account for the physical sightings, which were in turn explained away as a natural celestial phenomenon. Yet the matter has still not been explained to everyone's satisfaction. What are the chances of such misidentifications occurring simultaneously? Why were suggestions that the RAF be scrambled to investigate overruled? What of the police video purportedly taken of the 'object', which has seemingly vanished?

An incident early in the morning of Sunday 4 January 2009 also received widespread coverage. This concerned a 20-metre-long blade that was found at Conisholme Fen, having somehow broken away from one of the towering wind turbines at this isolated spot and plummeted to earth. Another blade was badly damaged and bent (although it didn't come off), almost as if something large and heavy had collided with the wind turbine 300 feet up, but left no trace of itself other than the damaged blades. Eventually, 'metal fatigue' was blamed, but as with the Wash Incident, not everyone is convinced. At the time, County Councillor Robert Palmer told the media he had seen a round, white light with a red tinge to its edge hovering over the wind turbines.

Looking out to the Wash.

What were the strange lights seen bothering the wind turbines at Conisholme?

Another eyewitness told the *Louth Leader* that, the evening before the event, she had seen a bright orange ball that seemed to pulsate somewhat, circling above the wind turbines. Were these witnesses mistaken in what they thought they saw? Would such a bizarre event occur once, and once only, if 'metal fatigue' or mechanical failure were to blame? If this accounted for the torn-off blade, what accounted for the bent and twisted one which remained in situ?

Whatever the explanation, this incident has now entered Lincolnshire's folklore.

Dancing Lights

A casual search of the internet will indicate just what a staggering array of green fireballs, luminous shapes and sinister black triangles have been seen in the skies over Lincolnshire. Some reports are mind-bending. In a letter to *Fortean Times* (Issue 63) a correspondent related a weird thing he and a school friend had observed one night in June 1975. It was a luminous white carriage-type object resembling a large pram without wheels that travelled slowly along Park Drive, Grimsby. Blurred round the edges, and where it joined the road, it moved at walking speed and rocked in a see-saw fashion. It was piloted by two figures, seated at either side, featureless and white, that looked like large skittles with circular heads. After two minutes it was lost to sight.

Not all encounters are this surreal and extreme, and a typical 'UFO' observation is as follows.

At around 21.05 on the night of Monday 19 December 2016 this author witnessed a peculiar spectacle over western Lincolnshire. The night was cold and clear, and from my back yard I could see two bright orb-like lights – one red, the other white-ish – moving steadily in tandem through the sky. They followed a horizontal course southward, approximately above the Trent Valley, and appeared much lower in the sky than the passenger planes and other commercial aircraft frequently spotted from this vantage point.

What happened next surprised and puzzled me. While still moving, both lights shot diametrically away from each other, before zooming back to their original positions to continue flying in formation. This trick the lights performed several times, and

Belief in aliens seems to have inspired this challenging graffiti at the Trent Viaduct.

each time they separated, the distance between them was so great that they became positioned in separate parts of the sky. Ultimately they zipped back to each other and continued to fly southwards in tandem.

Eventually I lost sight of the two mysterious lights. During this incident, I rushed inside to get a camera so as to film them, but upon returning outside I gave up immediately because, although the lights were clear to the naked eye, I judged them too far away to be caught by the camera. I originally thought it was a plane I was seeing, and each light represented the underside of a wing. However, when they separated, they zoomed off much too far away from each other for that to be the explanation. There was no question of them being lights projected from the ground either, which would have been impossible, for they continued to move south all the while and must have traversed miles. They were visible for perhaps five minutes. In my opinion, it looked like the two lights were flying horizontally side-by-side, but for a while started playing some kind of 'game' with each other, jumping around all over the sky as they did.

Had I been watching from a completely different vantage point, somewhere else in the county, perhaps the matter would have become entirely explicable. Nonetheless, I've never settled on an answer. The objects manoeuvred as though controlled, and nothing I know of could move in that manner. This is perhaps a 'typical' UFO sighting in Lincolnshire – something seen from far off which appears utterly inexplicable. Yet maybe it is the great distance involved that makes it so easy for the witness to interpret it as something 'unidentifiable'?

The Two Silent, Drifting Figures

Sometime around the beginning of the 1980s 'James', then at the age of around twelve, set off from his home on Benson Crescent, Doddington Park, Lincoln, on a midday

excursion to the Birchwood shopping centre. Much of the intervening land was at the time rough and undeveloped, covered with bushes, ditches, refuse and mounds of earth.

Walking across this barren expanse, James gradually became aware of how abnormally silent everything around him had become, despite the nearness of Birchwood Avenue: no people, planes, cars or birdsong. In this weird stillness he next realised that, around 400 yards behind him, there were two strange figures following the same path. (This was approximately between Pershore Way and Aldergrove Crescent, heading north.)

In relating this encounter to me around 2008, James stated that something immediately didn't look right about these figures. They walked side by side and were dressed entirely in black or dark clothes, which looked to be a type of oilskin. This dark clothing stretched from their shoulders all the way to their feet, but no arms or legs could be discerned, and the two weird figures appeared to be moving – 'drifting' – without motion. Their faces were dark and largely hidden underneath the brims of black, fedora-like hats on their heads. The thing that impressed him the most, however, was their height. These two people were absurdly tall, probably around 7 to 8 feet, and they appeared to be obscured by a kind of shimmering haze, similar to that of summertime.

Several times James looked back, only to see them the same distance behind him, until, when he was almost at the shopping precinct, looking over his shoulder he realised the two silent figures had vanished. Suddenly, it was like a switch had been flicked: cars passed by on Birchwood Avenue and people were suddenly about, entering and exiting the precinct's shops.

James recalls he found himself looking skyward for particularly dark clouds that might suggest the two figures had been 'beamed up'. From this, he indicated he considered his experience to be of a UFO-type nature, although in this author's opinion it doesn't really fit any pigeonhole exactly.

Men in Black

Perhaps James's experience falls into the category of 'Men in Black' sightings. These are mysterious men who feature in UFO lore, turning up at witnesses' houses to threaten and intimidate them into retracting their claims. Purporting to be from some quasi-government agency, their behaviour has been reported on occasion to be so disturbingly odd that it implies they are somehow alien. In 2012 declassified Ministry of Defence documents, published by the National Archives, revealed that several years earlier a woman in Spalding had been observed talking late one night to three tall men dressed in black suits. The three men had invited themselves into her house and questioned her in her bedroom following an alleged UFO sighting she had reported. The episode was witnessed by a third party, a friend, who happened to visit while the interview was taking place. The three strangers had scared the friend so much that she locked herself in the downstairs bathroom throughout the proceedings. The friend did not emerge until the Men in Black exited the property and left in a black Jaguar car. They 'seemed to move silently', according to reports in the national press. The odd thing about this was that the interviewee bore no recollection of her encounter with the intruders. The friend later persuaded the woman of the reality of the incident, so much so that she ended up ringing the police. The Men in Black's visit had the desired effect, however, for the woman also claimed she had forgotten ever seeing any UFO in the first place.

Newsflash from the Future

Around noon on 1 June 1974, Mrs Lesley Brennan, of Cleethorpes, was watching an old movie (*The Nevadan*) on television when it was interrupted by the word 'NEWSFLASH' filling the screen. A man's voice proceeded to announce that there had been an explosion at Flixborough, with a number of people killed and injured, followed by some technical details to which Mrs Brennan did not pay much attention, since she was eager to see the end of the movie. Nonetheless, the mention of Flixborough registered, since there was a chemical works there, owned by Nypro UK, which was a major employer in the area. (Flixborough is around 35 miles west of Cleethorpes.)

The movie then finished, and at around 12.20 two of Mrs Brennan's friends turned up for lunch. The friends were unaware of any incident at Flixborough, but the trio discussed how bad it might be.

The three friends were still together when the evening news came on TV, which sure enough led with the accident at Flixborough, where the chemical plant had suffered a massive explosion and fire, with many lives being lost. However, the news reported that the disaster had occurred around 5 pm.

As the reports continued to come in that evening and the next day, it became apparent that the incident had indeed occurred at 4:53 pm. It had been caused by an explosion of leaking cyclohexane, which vaporized the plant and caused people living in Scunthorpe to think there had been a nuclear attack on Britain when they heard the noise. Nearly thirty people were killed, dozens were injured and houses in Flixborough itself were destroyed.

There was no confusion over when the accident had occurred – it even stopped clocks locally, freezing the hands. So how on earth could Mrs Brennan have known about it five hours before it happened? When interviewed for *Arthur C. Clarke's World of Strange Powers* (3 April 1985), one of her friends, Peter East, confirmed Lesley had told him about it at lunchtime, and Lesley herself recalled feeling 'cold and shaky' when the inexplicable nature of what had happened hit her. Perhaps the most arresting thing about it all is that her premonition wasn't intuitive, rather informed by a mystery broadcaster, who seemed to know in advance that one of Britain's biggest peacetime explosions was to happen later that day.

Memorial to the tragedy in Flixborough's churchyard.

A Land of Miracles

Reports of religious miracles in Lincolnshire go back to Anglo-Saxon times. The Venerable Bede (d. 735) recorded that, a century earlier, 'a stone church of beautiful workmanship' had been built in Lincoln by the Christian missionary Paulinus. By Bede's time this had fallen into ruin, possibly thrown down by enemies. However, he described how the walls still stood, and each year 'miraculous cures' were wrought at the site. This primitive church is thought to have sat in Lincoln's Bail area, with a succession of churches dedicated to St Paul being built afterwards on the same spot. The last church was pulled down in the 1970s.

Bede also recorded one of England's most famous Anglo-Saxon miracles. When Queen Osthryth attempted to transfer the remains of her saintly uncle, King Oswald of Northumbria, to Bardney Abbey, he having fallen in battle *c.* 642, the monks refused to accept them. This was because they (as Mercians) resented Oswald as an enemy. Therefore, his relics were left in the open air overnight, on a wagon with a large tent spread over them. Throughout the whole night, a mysterious pillar of light was visible for miles, rising up into the heavens from the tent. The next day the panicking monks, fearing God's displeasure, washed the bones and accepted them reverently into the monastery, subsequently establishing a shrine for them. Interestingly, east of the abbey's earthworks, is an elongated mound called King's Hill; this, however, was not the site of the miracle, rather the resting place of Osthryth's husband King Ethelred.

Miracles took other forms too. Margaret, wife of Alan Everard of Burgh-le-Marsh, was tried by the justices for harbouring a thief (her son Robert) and sentenced to death. She was hanged on Canwick Hill, and after being cut down was taken for burial to the Hospital of the Holy Innocents on the Malandry Fields (western South Common), Lincoln. There, she suddenly drew breath and 'awoke' just prior to her burial. King Edward I himself granted her a pardon in 1284, declaring her survival was a miracle, and Margaret continued to live in the hospital for at least two more years.

The site of St Paul-in-the-Bail's Church today.

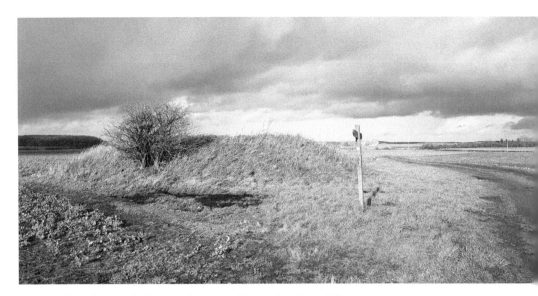

The burial mound of an Anglo-Saxon king at Bardney Abbey.

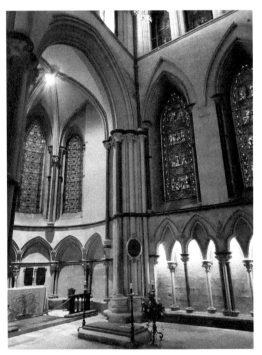

Above left: This is Bishop Grosseteste's tomb in Lincoln Cathedral. His death in 1253 was accompanied by strange lights and heavenly music upon the air. In the cathedral's vaults are said to be the fragments of his 'familiar', a magical talking head of brass.

Above right: At Stamford this knocker outside the gateway to Brazenose Hall is a replica of one brought here by students from Oxford in 1333. The original was fashioned by scholarly Friar Bacon and thought capable of speech – if the ring was pulled from its mouth while speaking, Stamford would be walled with brass.

Junction of Langworthgate and Greetwellgate, where the Virgin Mary allegedly appeared.

Medieval Lincoln was fertile ground for allegations of religious phenomena, particularly concerning the tombs of bishops in the cathedral. However, one story is eerily unique. There used to be a well, some 12 fathoms deep, in Eastgate, situated just before it divides into Langworthgate and Greetwellgate. According to an old Latin text, on 11 August 1498 Joanna Burton fell into it and was feared lost, there being 6 feet of water in the well. However, according to the testimony of nine other named women, Joanna was saved from drowning because she was cradled for an hour by an apparition of the Virgin Mary, who calmed her with soothing words and held onto her long enough for the rescuers to get her out with a rope. Nearby Lincoln Cathedral was, and still is, dedicated to the Blessed Virgin Mary.

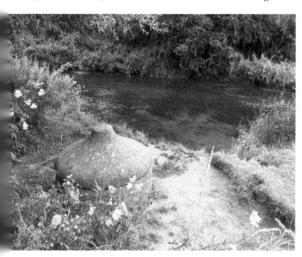

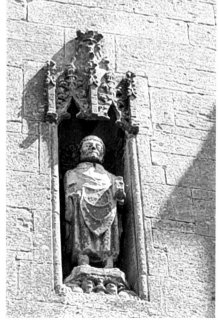

Above: A different type of miracle was alleged here at the Stamford Spa: that of its remarkable healing qualities.

Right: Guthlac defending Fishtoft from rats.

The tower of St Guthlac's Church at Fishtoft, near Boston, bears a stone effigy of Guthlac himself in a niche. Although the tower is probably fifteenth century, the statue is of much earlier workmanship, perhaps retained from a former incarnation of the church. Thomas Fuller's *Anglorum Speculum* (1684) reported, 'At Fishtoft no mice or rats are found, insomuch, that barns built party per pale, in this and the next parish, on one side are annoyed, on the other (being Fishtoft) are secured from this vermin.' As long as a stone whip remained in the statue's hand this would continue. Alas, even by the mid-1800s it was observed the hand bearing the whip, and the whip itself, had long since been broken away.

A Vision of Heaven

During Easter 1738 Frances Wright of Skellingthorpe fell into a thirty-six-hour trance. When she awoke, she told an incredible tale of her spirit having been taken on an astral journey to Heaven while her physical body lay unconscious.

Frances claimed 'a guide' had collected her and taken her across a river to a place where there were two entries. One was a long, dark smoke-filled passage, smelling of brimstone, which led to a wilderness place dominated by a great mountain, smoking 'like a charcoal pit'. This terrified Frances, so she was led instead via the second entry to a 'green court garden, with tall cedar trees round it, and borders of white flowers, and the sweetest music that ever I heard'. Here were Heaven's Gates, which were opened by 'an old grave man' who had a bunch of keys and a book in his hand. Looking in the book, the man told Frances her name was not in it and therefore she must return to the physical world.

That Christmas, Frances fell into a second trance, and was collected by her guide (a male) again. This time they were joined by a child from Saxilby, Mary Crook, who had died not long before. At 'Saxelby Bridge' Frances watched as the guide and Mary Crook collected her niece, whom she knew to be very ill. All four then went to Heaven's Gates where her niece and Mary Crook were admitted. This time Frances was briefly allowed through the gate, to sit in 'a two-arm'd chair all glittering gold' while angels rejoiced around her.

On Whitsun Monday 1740 Frances experienced a third vision, or astral journey, while in a trance, during which she experienced further heavenly glories. After

Frances seemed to suggest that the physical world's boundary crossed into the supernatural hereabouts at Saxilby's bridge.

she awoke, she received the holy sacrament from Revd Mapletoft of Lincoln. Her remarkable experience was reported in the *Christian's Amusement*, and perhaps the most fascinating aspect of this is the depiction of Heaven it presents us with.

Was Frances simply dreaming? Or, in her strange, prolonged trances, was she somehow allowed a 'preview' of what awaits us all?

John Wesley's Footprints

In summer 1742 the Methodist Church founder John Wesley was refused permission to officiate within St Andrew's Church, Epworth, and therefore he took his stand on his father Samuel's tombstone in the graveyard. This performance was enacted on other occasions when Wesley visited Epworth, and – according to legend – his bare feet somehow emblazoned their imprints onto the tombstone's solid, flat surface for ever more.

In the Victorian era there was great controversy over this supposed miracle. In 1866 a contributor to *Notes & Queries* wrote: 'When my father was young, he often heard the story about the footmarks, but cannot be positive as to any general belief about their miraculous nature. But he remembers his father taking him to see the tombstone "in the year of the great comet" (1811), and pointing out to him that they were merely iron stains, in order to show that there was no sufficient ground for a belief in their miraculous nature. From this it may be pretty fairly inferred that such belief had existed.' The contributor, Revd J. T. Fowler, when visiting the antiquity himself from Owston, learned from his cart driver (a local of fifty years) that 'I've heard 'em say 'at John Wesley did it with his toes when he knelt at prayer.'

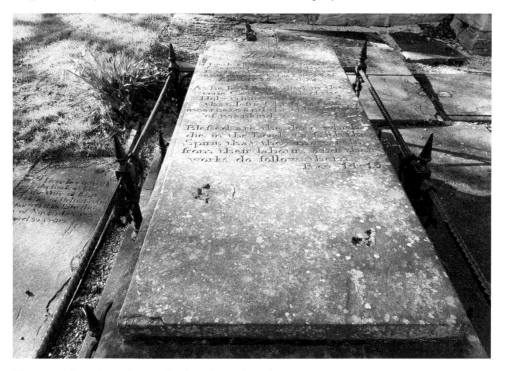

The miraculous 'footprints' still adorn Samuel Wesley's grave.

Even by 1866, belief in this 'miracle' appears to have become confined to a bygone age. Yet, incredibly, the marks on Samuel Wesley's tombstone are still there to be seen. The 'imprints' are about a yard apart in just the spots an orator would set his feet for firmness and authority. Furthermore, they are outside of the inscription to Samuel Wesley, one imagining that John Wesley would not have wished to step on the lettering, perhaps.

The Cross at the Window

In the early 1970s Wendy started work as a nurse at Scunthorpe's General Hospital on Church Lane. The hospital developed in the 1920s, following the formation of the Appleby-Frodingham Steel Company in the nineteenth century and Scunthorpe's subsequent growth.

Part of Wendy's shift involved working Ward 6. Here there was a men's unit, where at the time terminally ill patients were periodically brought when their condition took an irreversible downturn. This room had a large rectangular window, and one of the first things Wendy was told concerned a very odd hospital superstition.

This was to the effect that, shortly after someone had died on Ward 6, a phenomenon appeared outside the aforementioned window that took the form of a giant white floating cross. This supposedly looked misty, or cloudy, rather than 'solid', and would evaporate after a certain amount of time. In telling me this anecdote in September 2017 Wendy admitted to me that the allegations had thoroughly unnerved her during her time on Ward 6. However, she never saw the strange white cross herself, despite habitually looking towards the window on the first few occasions when patients died, to see if it displayed itself outside.

Wendy was adamant that it was a sincerely held belief among the staff at the hospital, and not a 'ghost story' told out of boredom to frighten new recruits. Upon reflection, she supposed that rumours of a phantom cross were quite old, perhaps dating back to the Second World War, since not one of her colleagues claimed to have seen it first-hand. However, a fellow nurse assured her that one of their predecessors – no longer working there – had 'definitely' seen it a few years earlier. She placed the alleged sighting sometime in the late 1950s or early 1960s.

Wendy herself is now long retired from working at the hospital.

The Dead Man Who Moved

In the eighteenth century Lincolnshire's criminals were publicly executed at the junction of Westgate and Burton Road, Lincoln. Women convicted of husband murder were occasionally burned at the stake, but most felons were hanged on a gallows. Long before a Horncastle executioner, William Marwood, introduced the 'long drop' technique of hanging, which clinically snapped the neck instantly, prisoners often struggled for minutes, dying of strangulation and kicking at nothing after a cart was drawn away beneath them.

One such execution was particularly macabre. On 27 March 1789, a chimney sweep called George Kilpike was hanged for robbing and 'violently abusing' Frances Norton on the highway – a crime he denied to the end. He even provided a witness, Elizabeth Bennett, to his having been in bed at the time of the offence. After Kilpike had been 'turn'd off some time' (according to the *Stamford Mercury*) his dangling

Face of the dead: the death mask of a burglar ('Tiger Tom'), hanged at Lincoln in 1830, adorns a private address in Horncastle.

cadaver shocked everyone by lifting up its right hand and placing it in his waistcoat; straight away, and in that position, it was confirmed Kilpike was actually dead.

At the very least, the unconscious Kilpike must have been hovering on the brink of eternity when his body suddenly animated itself. One is left wondering whether Kilpike even knew he'd performed this last movement. Was he, in fact, already clinically dead? Could it have been one last muscular post-mortem twitch, caused by a final spark of life's electricity, in a man who had already died?

The Preserved Cadaver

In 1831, Stixwould's St Peter's Church was rebuilt, and during this work a great many coffins were emptied and the bodies reburied in a communal grave in the churchyard's south-east corner. One coffin, belonging to Mrs Elmherst, was found to contain the body of a beautiful young woman with golden hair, together with a baby – both preserved so completely it was as if they were asleep. Revd Penny (who died in 1944, aged ninety) was later told by one of the workmen present that these bodies almost instantly crumbled away to dust.

Here at Sempringham, this boulder was raised in memory of a medieval Welsh princess, Gwenllian, imprisoned at the nearby priory. People say if you stand on the bridge and view the side aspect, the silhouette of a nun, head bowed, reveals itself on the stone.

Greatford's church, where coffins moved about by themselves.

Moving Coffins

In 1867 *Notes & Queries* published a letter from F. A. Padley, recalling a strange mystery that had been discovered in the vaults of St Thomas' Church, Greatford, near Stamford. Some twenty years previously, when Padley's father had been rector, on at least two occasions the church vault had been unlocked in the course of normal church business and multiple coffins within found completely disarranged, as if moved about by some invisible force. On one occasion, a small coffin had somehow transported itself onto the top of a larger one, with others tilted on one side against a wall.

The vault had been secured, so access to it was not easy; furthermore, some coffins, leaden and cased in wood, were so heavy six people would struggle to lift them. Padley reported that the matter had caused much superstitious concern at the time, and was hushed up. The only explanation was that somehow the vault had become flooded, floating the coffins into their peculiar positions.

The West Glen River meanders near the church's eastern side, but how such extensive flooding by it could affect the church without anyone noticing remains a mystery – as do the reasons for the phenomenon suddenly starting, then stopping, after only two (or possibly three) events.

Into Thin Air

In 1734 a 'village of Lincolnshire' (we are not told where) was the setting for a dramatic mystery.

A great many people were assembled in the drawing room of a house to celebrate the wedding of Mr and Mrs Griffin. Around noon, a servant entered and quietly informed Mr Griffin that 'a gentleman' had called at the house, asking to speak to

him, and was currently waiting below stairs. The visitor would not come up since he came on very private business. Mr Griffin excused himself to his wife and guests, saying he would be back in a few minutes. He left the room and was last seen by the servants walking into the garden with his mysterious visitor.

No one wished to interrupt Griffin's private discourse with the stranger, and therefore it was four hours before his wife and guests began to voice concern about his continued absence. A search began for him, starting in the spacious garden, which was found to be empty; moreover, it was enclosed by a high wall, impossible to climb over without the aid of a ladder. No such equipment was found. Neither could Mr Griffin and 'the gentleman' have walked through the house and exited the property by a front door without being seen by either the servants or the guests.

Quite simply, nothing was ever heard of Mr Griffin again. His wife lived to be nearly ninety years of age without ever receiving any information as to what may have happened to him.

The story appeared in *Chambers Edinburgh Journal* (1835), citing the *Lincolnshire Chronicle*.

Another legend concerning a weird disappearance comes from Kirkstead Abbey, south of Woodhall Spa. Only a portion of masonry and earthworks remain of the twelfth-century abbey, while on the opposite side of the track is a very clear depression in the land that angles towards the south-west corner of the moat. This channel is said to indicate the start of a tunnel that led to Tattershall Castle, although the entrance is now long closed. Centuries ago, a crowd of people watched an explorer go into the tunnel to determine if it did, indeed, lead to the castle. He took with him a bugle, which he said he would sound if he encountered trouble, and a dog. Sometime after he had set off, those assembled heard the bugle sound from a subterranean position a very long way off, and next the dog bolted out of the entrance in a state of utter terror, dashing into the countryside without being caught. The bugle sounded several times more from below ground, ever fainter, then ceased, but the villagers dared not venture into the tunnel themselves. The explorer was never seen again after that.

In reality the 'tunnel' was probably a subterranean sewer passing beneath the moat. Of Kirkstead Abbey, J. C. Walter's *Records of Woodhall Spa* (1899) relates: 'A local

Kirkstead Abbey.

tradition survives, that the place is haunted by a headless lady.' However, there is no suggestion she took the missing explorer.

While these stories have the ring of folklore about them, rather than real events, in March 1870 many newspapers reported on a genuine mystery. This concerned the schooner *Clio*, out of Lowestoft, which was washed ashore at Cleethorpes and found to be completely deserted. The *Clio's* empty lifeboat was subsequently also found washed ashore near Cleethorpes, 'with her oars lashed to her'. It was speculated that the *Clio* may have become stranded on the sand and gravel banks called Stony Binks at Spurn Head during the ebb tide and was then deluged with sudden heavy seas that washed the crew, midship bulwarks and lifeboat overboard. As the water rose again, she floated off, drifting to where she came ashore. However, the mystery was never solved – for Captain Fuller and his crewmen were never found.

Urban Panics

In March 1922 rumours swept Stamford that a man wearing a mask prowled the suburbs after dark, molesting and violently assaulting women and cutting off clumps of their hair. False reports of a suspect's arrest circulated, including one account suggesting he had been taken into custody after attempting to embrace a policeman dressed in female attire as a decoy. The panic these stories created was very real: women took to arming themselves with sticks and taking dogs with them if they had to leave the house. Nonetheless, no arrest was announced, and the newspapers reported that there was a growing tendency to regard the prowler as mythical.

Social panics like this often concern the threat of violence from some shadowy assailant who may or may not exist in reality. For example, in 1935, Mr Watson, tenant of Lea Hall near Gainsborough, received a letter purporting to come from the notorious 'Phantom Avenger', whose malicious threats of violence and fire-raising had already caused panic and alarm in many parts of England. In some cases, his words had coincided with actual acts of vandalism and arson. Ominously stating 'I am coming into your district' and threatening outrages, the 'Phantom's' letter prompted police to guard Lea Hall on 13 December, although the night was very foggy and they saw no one. When it emerged Watson had subsequently received more letters from the 'Phantom', claiming he had visited the hall around this time, but 'found the police nosing around', a state of genuine fear gripped the district. However, it was never fully established who the 'Phantom Avenger' was, or whether he even existed as suggested – that is as a lone-wolf terrorist hell-bent on destabilizing the country.

Many urban panics involve rumours of sinister humans apparently on the brink of doing something dreadful. Since the early 1990s there have been sporadic reports in Lincolnshire of houses being visited by mysterious callers purporting to be social workers, including at Lincoln and Kirton-in-Lindsey in 2000. Worryingly, they have on occasion supposedly tried to gain access to children on the premises, but left abruptly when challenged. Subsequent enquiries by parents always discover the callers were not connected to any local authority, despite their claims.

However, sometimes it can be difficult to gauge exactly what combination of circumstances causes a social panic to develop. Today, few will forget the 'Killer Clown' scares of recent years. The first wave of sightings came in late 2013. People dressed in clown masks and garb, behaving in an unsettling manner, were spotted in Boston, Wyberton,

Hykeham, Waddington, Scunthorpe, Gainsborough, Market Rasen and on Lincoln's Ermine estate. The 'Ermine Clown' was actually photographed on Woodhall Drive.

Worse followed in October 2016, when Lincolnshire police were called out sixty-one times by people who believed they had seen sinister figures dressed in clown costumes and masks, acting aggressively and terrifying strangers. As in 2013 what percentage of the allegations were genuine remains unclear, although there were arrests on at least one occasion this time. These followed reports that a silver car full of people wearing clown masks was terrifying people and causing havoc in Scunthorpe.

On 17 October 2018, there were rumours a mysterious man in a frightening clown mask had been appearing at people's windows in Market Rasen, around 10 o'clock, knocking on the glass to attract their attention and then simply glaring at them from outside. Panic swept the town. People began taking to social media to report the clown was hiding in Queen Street, or leaping out on people. The following month, someone in a creepy clown mask reportedly followed a group of people to a property on Lincoln's High Street and then stood outside, looking up at the window and screaming at them even as they called the police.

Rarely does anyone ever seem to be arrested, and a subcategory of folklore seems to be developing around suggestions that, on many occasions, there never was a clown in the first place.

Spring-heeled Jack

Such scares are a reminder of older Victorian social panics, like that of London's bounding demon Spring-heeled Jack, a version of whom, incidentally, visited Lincoln in 1877. The *Illustrated Police News* (3 November) reported that a figure dressed in something like a sheepskin, with a long white tail, was terrorising the city, apparently possessing the ability to leap 20 feet and run along rooftops. He was even shot at as he scaled the third-century Roman Newport Arch, and fired at again later as he ran on the wall of the 'new barracks' (on Burton Road), both times with no effect. This story was borne out to an extent by a letter to the *Lincolnshire Chronicle* in 1938

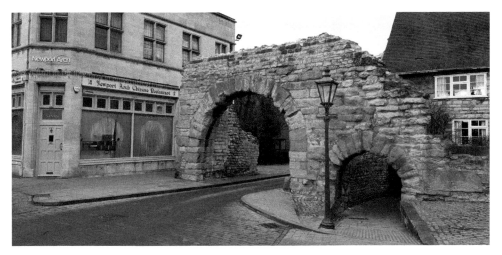

Someone, or something, akin to Spring-heeled Jack scaled Newport Arch.

from Mr J. Rollings: 'In 1877 I lived at a farm in Newport, owned by a Mr Herd. The farm faced the Turk's Head. In that winter, Spring-heeled Jack came to Lincoln and jumped over Newport Arch, and at nights the young men of the town used to come out and try to catch him.'

In 2019 I was told (unprompted) by a resident of North Hykeham that she had grown up understanding Spring Hill, in Lincoln Castle's shadow, was so-called because it was where the bogeyman was last seen 'bounding, or springing, up the hill' towards what would then have been the Lincoln Lunatic Asylum, now The Lawn. Make of that what you will.

Phantom Distress Calls

In times gone by they spoke of a fabled town of great importance. Walled and with a castle, this place sat 4 or 5 miles off Skegness in the Wash. However, even by the time the Tudor-era traveller Leland collected the legend, the town had long been devoured by the encroaching sea, although 'At low waters, appear yet manifest tokens of old buildings.' Tradition names this Lincolnshire Atlantis 'Wilegripe' (although that may be a misinterpretation of Leland's wording). In 1936 the *Boston Guardian* reported that bathers were claiming to hear church bells ringing beneath the waves, and that a drifter, the *Golden Spray*, had recovered a large piece of manufactured masonry from the sea bed, perhaps a portion of Wilegripe's submerged castle.

The following year, however, an entirely new mystery developed off this part of Lincolnshire's coast.

Between around 10:45 and 11:20 on the night of 30 December 1937, flares were reported off the Skegness coast, indicating a vessel in distress. This was a little surprising, because the night sea was calm, but nonetheless the Skegness lifeboat was launched.

The report had originated in Mablethorpe and indicated the Inner Dowsing Lightship might be in distress at sea. However, when the Skegness lifeboat reached that vessel, coxswain George Perrin and his crew were told by the occupants that the 'distress flares' had in fact been noticed at a point south-west of their location. The lifeboat headed where indicated and for five hours searched the seas, but found nothing to account for the sighting.

The report was backed up by a party of road travellers between Lincoln and Skegness, who stated that, when at the top of the hill near Wragby, they saw 'coloured lights' out at sea. Local people spoke of seeing 'flares or rockets' over the water.

No evidence of a missing vessel turned up, and beyond this no explanation was forthcoming. What is worryingly eerie is that this phenomenon has repeated itself up to the present day – still with no real explanation. At 4.30 am on 11 August 1939 the lifeboat (on the east side of South Parade, Skegness) was drawn up in response to a report from the local coastguard that distress flares had been observed in the Wash 3 miles off Boston. The incident had occurred shortly after a wartime 'black-out exercise' over the area. When it was ascertained all planes taking part were accounted for, and following a search of the area by a high-powered speedboat from Norfolk (which found nothing), the Skegness lifeboat was stood down. This mysterious report originated with the Mablethorpe coastguard authorities, citing advice received from Kings Lynn of the flares.

At 8:30 pm on 1 November 1945 the lifeboat was launched following messages from the Skegness and Mablethorpe coastguards that flares, or lights, had been seen

This skeletal tank on the lonely dunes north of Trusthorpe is said to have been used by the RAF for bombing practice, but what accounts for the lights out at sea?

around 6 miles out to sea. The search, conducted over four hours in rough seas, found nothing. Mysterious red flares on the evening of 26 October 1950, first seen 5 miles south-east of Chapel St Leonards, then 15 miles off Mablethorpe, resulted in the lifeboat being called out twice over eight hours, both times fruitlessly. On the evening of 30 April 1974 the Skegness lifeboat made another fruitless search, over five hours, after red distress flares were reported out at sea in the Wash.

What are they? An unidentified natural phenomenon? Ghostly echoes of some real-life sea tragedy long ago, where a distress flare was fired but no help came? If criminals out at sea are signalling by using flares, why do prompt searches find the sea empty? And why would criminals 'advertise' their position in such a manner anyway? Sometimes there is a vague supposition these 'phantom flares' are to do with RAF night exercises, but this never seems to be confirmed, and one would assume the coastguard might be forewarned of such events to forestall any misunderstanding that could subsequently lead the Skegness lifeboat unnecessarily into dangerous waters.

On the evening of 26 February 2019 Mablethorpe coastguards were alerted to 'flares' seen out at sea between Trusthorpe Point and Sutton on Sea. On their Facebook page they advised the public, 'On arrival to scene we searched the area and from Sutton on Sea we could spot orange lights coming on and off out to sea. The lights seen were not typical of what we would expect to see from a distress flare.' The lights were categorised as not distress flares, and the operation stood down. Reportedly, a number of people saw these mysterious lights from the Skegness area.

There had been some RAF activity in the Donna Nook area earlier that afternoon, but – again – there was no definitive connection with the 'orange lights' and this strange mystery is, at the time of writing, unsolved.

Earthquake Lights

Still largely unexplained are the strange lights that accompany earth tremors in Lincolnshire. In 1755 something was seen in the sky resembling a large ball of fire around the time an earthquake rumbled its way through the county on 1 August. The air was observed to be 'loaded with vast quantities of sulphur'.

Coinciding with the 27 February 2008 earthquake, which had its epicentre near Market Rasen and occurred near 1:00 am, a grapefruit-sized ball of lightning reportedly invaded a pensioner's bedroom in Westgate, Louth, before disappearing in front of her. Odd, unexplained flashes of light illuminating the sky were reported from Sleaford and the Wolds at the same time.

Ball lightning is not unknown in Lincolnshire. On 3 September 1800, during a tremendous storm, it entered the window of a house at Market Deeping, causing severe damage to its contents and numbing the occupants before managing to navigate itself an exit by breaking a windowpane. Also, on 18 September 1923 a Cleethorpes boilermaker, George Beeson, was killed after ball lightning, 3 feet in diameter, came rolling through the sky during a thunderstorm. It hit a chimney stack in Church Street, Grimsby, causing it to explode and fall on Beeson, fatally injuring him.

But why – and how – this natural wonder could perform such a trick to coincide with the 2008 earthquake is still only speculatively explained.

Natural Phenomena

Natural phenomena, even though not necessarily paranormal, can nonetheless be equally perplexing, as this miscellaneous round-up evidences. In May 1697 the Yorkshire antiquary Abraham de la Pryme recorded in his diary: 'This day I was at Brigg, towards night, and meeting with a very ingenious countryman he tells me that but a while ago, he saw a huge ash tree cut in two, in the very heart of which was a toad, which dyed as soon as it got out. There was no place for it to get in, all was as firm as it could be.'

Sometimes, veneration of Lincolnshire's natural landscape can appear to cross the boundary between the physical and the supernatural. Of the ancient turf maze at Alkborough, J. F. of Winterton wrote in 1866 to *Notes & Queries* that over sixty-five years ago, villagers played May eve games there 'under an indefinite persuasion of something unseen and unknown co-operating with them'.

Folklorist Edward Peacock's 1877 glossary of words used east of Gainsborough refers to star-shot, 'a kind of white jelly often found in pastures'. This strange gelatinous

Alkborough's turf maze, looking towards the Humber.

ubstance, often discovered following rainstorms, was sometimes considered the deposited remains of a shooting star, although its precise origin is still debated.

The *Lincolnshire Echo* (17 January 1950) published an aerial photo, taken by the Air Ministry one May 'some time ago', of Lincoln's West Common. The photograph captured a gigantic, perfect circle of white north of the tennis courts at the foot of the Common's slopes. The circle was probably around 1,000 feet in diameter and its circumference outline was thicker than nearby roads; yet built-up areas obscured it – almost as if it was somehow radiating up from beneath the ground. There was nothing at ground level suggesting any natural formation that might have caused the white ring's presence. In the photograph, it appears almost luminous.

On the afternoon of 22 July 1976 the sky above Lincoln was darkened not by rain, but by masses of straw, which blew in from the north and deluged the city and surrounding area in prodigious quantities. A light aircraft west of Waddington reported that 'haystacks' were visible at an altitude of 3,000–4,000 feet. Localised whirlwinds were supposed, yet the exact mechanics of how this would pick up straw only are still a mystery. So too where the straw was meant to have been lifted from.

It merely illustrates that we have yet to understand some of the enigmas of the natural world before we can even attempt to contemplate those of the paranormal world.

An example of 'star-shot' (discovered western Lincolnshire around five years ago).

Here at Nettleham, a final mystery. Grass will not grow, and never has done, at the grave of Thomas Gardiner, murdered in 1733.

Acknowledgements

Many thanks to Roger Parsons, for his thoughts on the 'Werewolf of Dogdyke'; Marion Seviour, for allowing me to reproduce the article on the green-faced ghost from *Chatterbox Magazine* (No.277 February 2011); R. Starmer, T. Cooper, C. Smith, N. Stone, B. Knotts, A. Brien, A. Meacock, E. Healey and E. Ashworth for their anecdotes on contemporary Lincolnshire folklore; Charlie Skinner for passing on the 'greedy skull' gargoyle tradition at Lincoln Cathedral; Victoria Mason Hines, Visitor Experience Manager, Gainsborough Old Hall (for more info on this historic hall see www.gainsborougholdhall.com); staff at Browns Pie Shop, for their interesting information and fine food; Matt at The Old School Inn, Epworth, for sharing information with me on the pub's eerie 1949 photograph of the 'boy with the blurred face' (Covid restrictions hampered my investigation into this); Rich Storey, Mayor's Officer, for showing me the Guildhall's subterranean cells and alerting me to the ghost there; Owen Teather and Zena Herring, for allowing us of an old image of the Stonebow, from a private album; Dr Rob Gandy, for furnishing me with the Boultham and Scunthorpe stories in 'The Ongoing Mystery' from his own research; Scotton Parish Council; Sue Walker and David Smith, for their help with Dickie Rainsforth's legend; Claire Birch, Owner & Chief Executive, Doddington Hall, and Mason at Branston Hall, for their help in trying to confirm hauntings at both locations.

Finally, thank you to Back2Back Productions Ltd, for inviting me to appear on their TV show 'Help! My House is Haunted', thereby giving me an insight into how 'ghost hunts' are conducted in the twenty-first century. The episode concerned involved the seventeenth-century Black Dog inn on Watergate, Grantham. During an earlier investigation in February 2020 by a paranormal group at the pub, live streamed via Facebook, some viewers thought they glimpsed the apparition of a monk in the cellar. There are rumours of tunnels beneath Grantham, and at one time a Franciscan priory was situated a stone's throw from the pub. This author speculated that the Black Dog was inadvertently built on the site of a pre-existing tunnel running between the priory and Grantham's church, and perhaps the pub's cellar was fashioned from part of the tunnel, hypothetically accounting for a 'monk' there. All speculative of course, but it has brought home the fact that in the age of digitally enhanced images, social media, live streaming, television investigations and so on, the supernatural still firmly has a place.